HOW TO PAINT
living
PORTRAITS

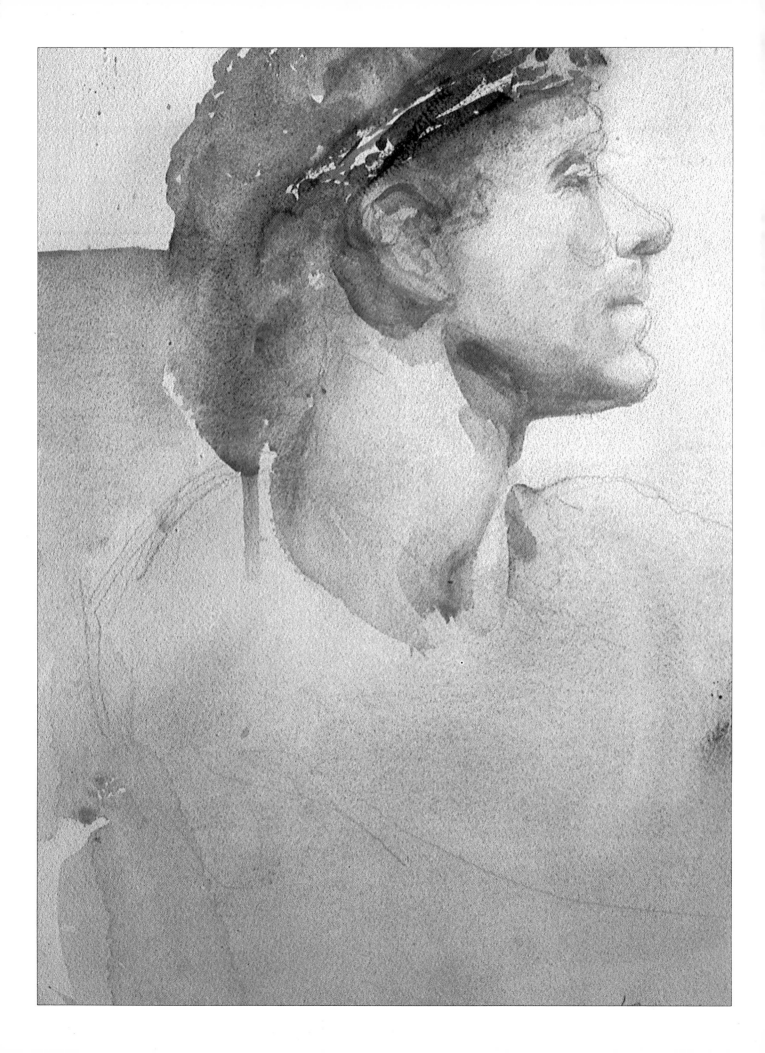

HOW·TO·PAINT
Living
PORTRAITS

ROBERTA CARTER CLARK

NORTH
LIGHT
BOOKS

Cincinnati, Ohio

Four years went by between the time this book was started and its completion. I wish to thank Mary Kennan for encouraging me to begin, and my family and friends for their patience and loyalty as I struggled to wrestle this monster to the ground.

Heartfelt gratitude also goes to Wendy Jennings for working so closely with me on the photography; to Patricia Lafferty for the jacket photo; to Andrea Ericson Hogan, the former director of Portraits, Inc., for her support and for sharing her intimate knowledge of contemporary portraiture; to Nancy Hale Bowers and to Prescott D. Schutz of Hirschl and Adler Galleries, Inc., who helped me track down the work of Lilian Westcott Hale, Mrs. Bowers' mother; to Nonda Biemiller, art teacher and good friend, who volunteered to be the first to read the entire manuscript; and to my editors, Bonnie Silverstein and Kathy Kipp, who, with their sensitivity and vast knowledge, whipped all my words and pictures into a finished work, never doubting the value of this project.

A special "Thank You" goes to my son, Dean Fittinger, for giving so freely of his time and energy, devotion and dedication, thereby helping immeasurably to bring this effort to conclusion.

—Roberta Carter Clark

How to Paint Living Portraits. Copyright © 1990 by Roberta Carter Clark. Printed and bound in Hong Kong. All rights reserved. No part of this book may be reproduced in any form or by any electronic or mechanical means including information storage and retrieval systems without permission in writing from the publisher, except by a reviewer, who may quote brief passages in a review. Published by North Light Books, an imprint of F&W Publications, Inc., 1507 Dana Avenue, Cincinnati, Ohio, 45207. First edition.

94 93 5 4 3

Library of Congress Cataloging in Publication Data

Clark, Roberta Carter.
 How to paint living portraits / Roberta Carter Clark.
 p. cm.
 Includes bibliographical references.
 ISBN 0-89134-326-1
 1. Portrait painting—Technique. I. Title.
ND1302.C54 1990 89-27776
751.45'42—dc20 CIP

The self-portrait on the jacket painted by Roberta Carter Clark.

This book is dedicated to Judi, Dean and D. E., with love.

C O N T E N T S

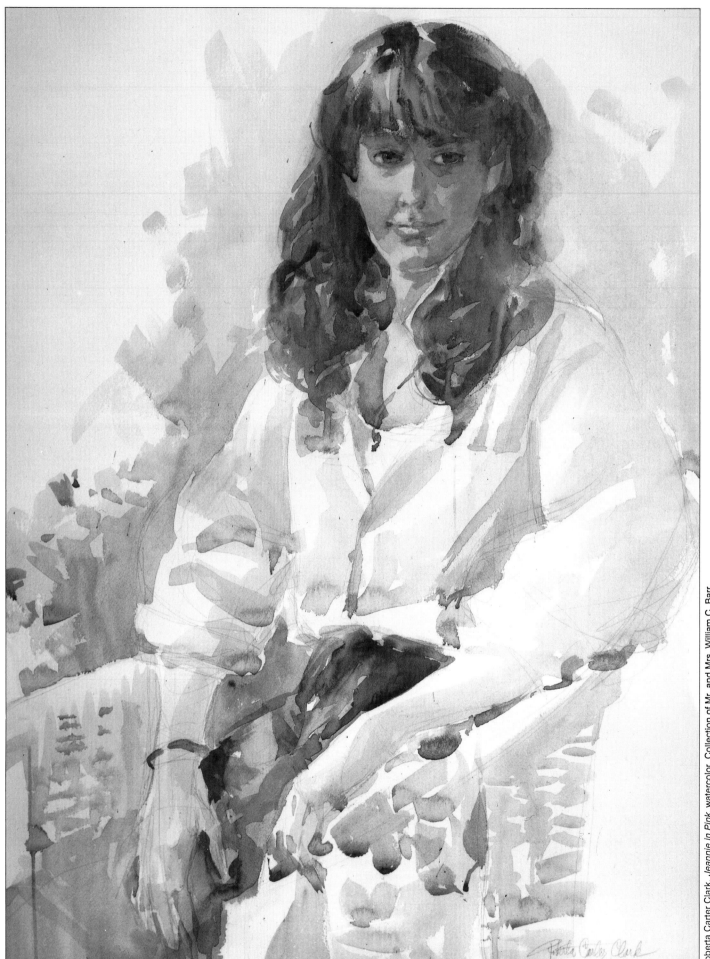

P R E F A C E

Those of us who are interested in producing a portrait of another human being are usually so enchanted by this prospect that every other kind of artistic endeavor pales by comparison.

It's an interesting phenomenon that every person on our planet has two eyes, one nose, and one mouth, and yet each of us looks completely different from everyone else. This is the uniqueness that the portrait painter must catch. This "differentness" plus the specific personality projected make up what we call "the likeness," and the painter's skill and sensitivity in being able to capture these elements are what make the portrait successful.

I'm hoping that you have had some previous experience in drawing and painting before tackling this book. To learn the use of charcoal, oil, and watercolors by painting people is a most difficult task, and as a beginner, you may lay down your tools in frustration. However, once you've had some success with faces you may never again find the same sort of excitement depicting landscapes and still life.

If you can achieve a recognizable image in charcoal and understand something about mixing and applying colors, you will gain a great deal from this book. Just remember, no one is born knowing how to paint a portrait. Each of us has to learn — by studying, thinking, and working. If you have the desire, you will surely learn too.

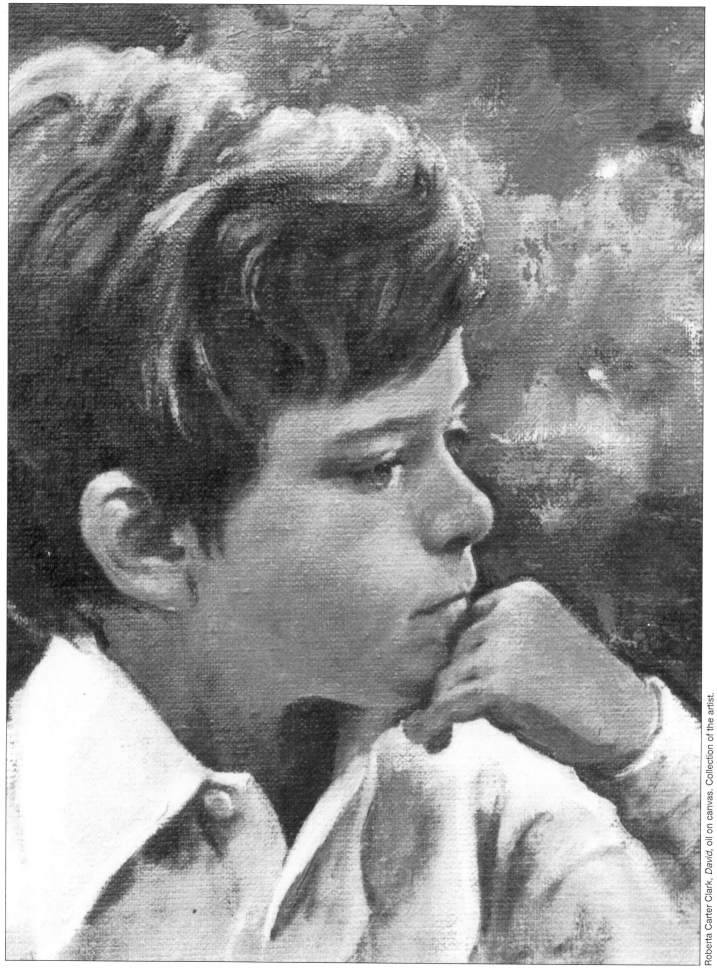

Roberta Carter Clark, *David*, oil on canvas. Collection of the artist.

THE PROPORTIONS OF THE HEAD

The success of a portrait is largely determined by how well the parts of the head interrelate: how the nose relates to the ears, the mouth to the jaw, the eyes to the nose, the facial area to the head—all these things must be discovered. This isn't overwhelming if you have a plan or blueprint of the way these parts fit together.

Considering Solid Forms

Before we can draw and paint portraits we must learn to simplify very complex subject matter—the human head and body. Every portrait painter trains him or herself to perceive these forms in simple masses, overlooking details until the larger forms are satisfactory.

It is possible to draw a head shape using line alone. A circle is a basic beginning, but an egg shape resembles the human head more closely:

If we want to draw or paint a head that will appear to look solid, round, three dimensional, we have to begin to think about light and shadow and how to add these elements to our linear egg shape.

First we need to decide where the light source is that shines on this egg-shaped head. Study the drawings below. The part of the form that faces the light source is our light area, *A*. Another part will receive no light, the shadow area, *B*. Notice that this very distinct jump from light to shadow really doesn't help to indicate round form—do you agree?

We need an intermediate step between the light and the shadow. This transition step is called the *halftone*. It is a very narrow area, *C*, which indicates a rounding of the form from the light area into the shadow area.

Now we are thinking in terms of light, shadow, and halftone, but there is one more element to consider—*reflected light*. If our ovoid head form were on a body wearing a colored garment, we would see that color reflected up into the shadow area on the jaw or under the chin, *D*. This bounced light is subtle and *never* as light as the halftone: Remember that reflected light is part of the shadow, and if it is made too light the head will no longer appear solid.

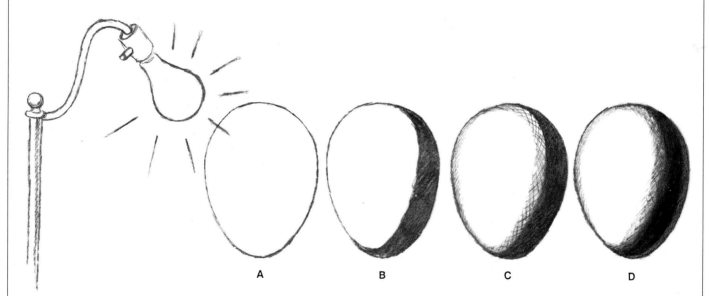

A B C D

Exercise: With pencil or pen and paper try drawing *A, B, C,* and *D* yourself. After about twenty oval "heads" you will find you can draw these solid forms with ease and understanding.

In these drawings we have used shadow to define form. Artists call this "modeling the form." We look for the *lights* first, but the only way the lights can be defined on white paper is to draw in the *shadow* first. This makes the "seeing process" different from the "doing process."

Step-by-Step: **Making an Egg Head**

As a prelude to working with an actual head, we'll learn about the relationships between light and dark by using an actual egg. Experimenting with an egg head has an advantage at the beginning of your study of the head and features: You can set it at any angle you choose—yet it won't move. To make an egg head, take an egg and make a hole in each end with a pin. Hold the egg over a bowl and blow into one end, and the inside will come out, leaving the empty shell. Rinse it out with clean water, handling it carefully. (When you begin to use your egg as a model to draw form, you'll find you can make it stand on end by using an empty pill bottle or a bottle cap as a base.)

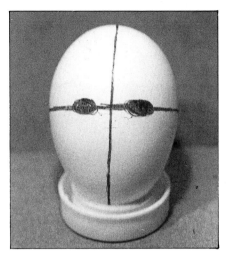

1. Hold the egg upright and draw a line with a fine marker or a pencil straight down the shell's center, top to bottom. Now draw a second line horizontally around the egg, halfway down and at right angles to the first line. On either side of the vertical line, draw eye ovals on the horizontal line—this is called the "eyeline."

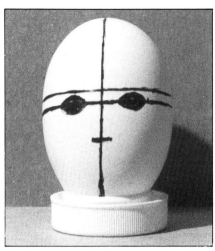

2. Add a second horizontal line just above the eye ovals. This will be the "eyebrow line." Now, not quite halfway down between the eyebrow line and the very bottom of the egg, make a mark for a nose, crossing the central vertical.

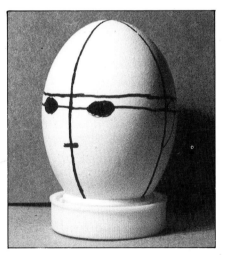

3. Now try turning the egg a quarter turn to the right. You may need to add another vertical line from top to bottom halfway around the side where the ear would be. The egg now resembles a football.

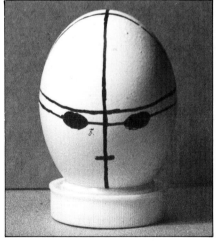

4. Tilt the egg slightly forward and you will see the eyeline appears to round downward at the center front and curve up at the sides. This curve is what makes the head "look down."

Lighting the Egg

Hold the eggshell so the brightest light from a window or a spotlight strikes it at the upper left front, and study the shadows on the shell. Do you notice the way these shadows change with even the slightest tilting of the shell? Place the egg on the stand so the shadow pattern remains constant. You'll see several different types of lights and shadows on and around the egg. Between the light and shadow areas on the "face," you'll see the halftone. (You'll always see the halftone on planes where the light is deflected from the face and glances off of it.)

Now draw the egg, indicating the light, shadow, and halftone areas as you see them, and letting your strokes go across the form. You now have your first "head." Add mouth, ears, hair, and a neck, if you wish.

Exercise: Make twenty drawings of egg heads, tipping your egg slightly to the right and left. Also try turning it a quarter turn to the right, then left, or looking up or down. For three-quarter views you may need to add another vertical line from top to bottom halfway around on both sides where the ears would be. (The egg will then resemble a football.)

Note: When you add mouth lines to your ovals, think of the mouth line as closer to the nose mark, not halfway between the nose and the base of the egg.

Cast Shadows and Reflected Light

On a real head, you'll also notice cast shadows and reflected light. The cast shadow is very important, though in portraits it's somewhat subtle. We see it, for instance, when the nose casts its shadow on the curve of the cheek or on the area between the nose and the upper lip. Or when the chin, as it projects, casts its shadow on the cylinder of the neck. The cast shadow tells us something about the size and the shape of the object casting the shadow. It also describes the contour of the surface on which the shadow falls. It makes the features look "real" (three dimensional) and tells us the light direction. A final element to consider in modeling form is reflected light, which, in a way, is the opposite of a cast shadow. When the light source shines so brightly that the light bounces off a light-colored shape, like a shirt or blouse, and back onto the face, the bounced light is aptly termed "reflected light." Reflected light is subtle, and never as light as the halftone. If you make the reflected light too light, the solidity of the form will be destroyed.

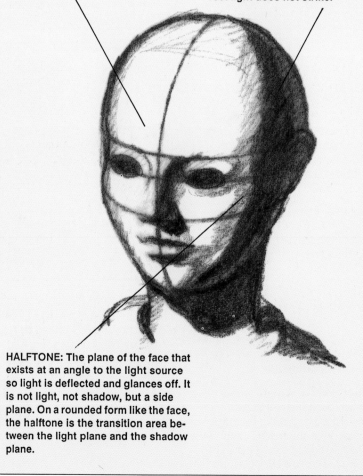

LIGHT: The part of the head facing the light source.

SHADOW: The area of the head facing away from the light source where direct light does not strike.

HALFTONE: The plane of the face that exists at an angle to the light source so light is deflected and glances off. It is not light, not shadow, but a side plane. On a rounded form like the face, the halftone is the transition area between the light plane and the shadow plane.

Step-by-Step: **Drawing the Adult Male Head in Profile**

When drawing the head, it's important to know what to look for even before you have a model. On the following pages, you'll find methods of constructing the head and for accurately drawing proportions for heads from babyhood to old age. Draw the diagrams again and again until you can do them with ease. Copy the diagrams at first, then draw from imagination. Don't use mechanical devices; try to train your eye to judge relationships. Think about what you're doing.

You'll need a pen or pencil, paper, kneaded eraser, and ruler (also graph paper, if you wish) for these exercises. For a change of pace, you may want to draw the proportional divisions you'll work with here over photographs of heads in magazines. This should help carry you from the idealized proportions you'll learn here to actual ones of real people of all ages and types. You'll be amazed at the variety you'll find.

Since the most basic way to get a likeness is in profile, we'll begin with that. The drawings you'll study on the following pages are based on two-inch squares, each divided into four one-inch squares. On your paper, make several squares in ink (or use graph paper), and chart the heads on them in pencil. In actuality, the life-size head of a six-foot tall Caucasian male would measure nine inches from the top of the skull to the bottom of the chin, and nine inches from the tip of the nose to the back of the skull.

1. Place the eye on the horizontal halfway mark (*1-3*) as if the line passed through the lower eyelid. (The eye is actually halfway down the head.)

2. Divide the left edge of the square into seven equal parts. Try to measure by eye, not with a ruler.

3. The eyebrow sits at line *c*, along with the forward projection of the skull above the eyeball.

4. The bottom of the nose sits at *e*, halfway between brow line and chin line. There is a wing of cartilage flaring over the nostril, and the bottom of that curve is on line *e*. The tip of the nose may turn up above that line or curve down below it.

5. The top of the ear also lines up with the eyebrow at *c*. The bottom of the earlobe lines up with *e* at the base of the nose. The ear is placed at the vertical halfway mark (*2-4*) extending toward the back of the skull.

6. Draw the forehead up from *c* in a squared curve to top center *2* and continue in the squared curve to *3* at the back of the skull. Continue the curve until a point level with the base of the nose and ear is reached, lined up with *e*, forming the base of the skull.

7. The mouth is between *e* and *f*, with the lower lip projecting above *f*. Drop a chin line to *g* on the bottom line and extend it to *h*.

8. Now, with a slight curve, draw the jawline from *h* to the back of the skull with a dashed line.

9. Sketch a light diagonal line from the brow projection at *c* through *h* under the chin for the front of the neck.

10. Parallel to the line you just drew, draw a diagonal line from the top of the skull at *2*, through the base of the skull for the back of the neck.

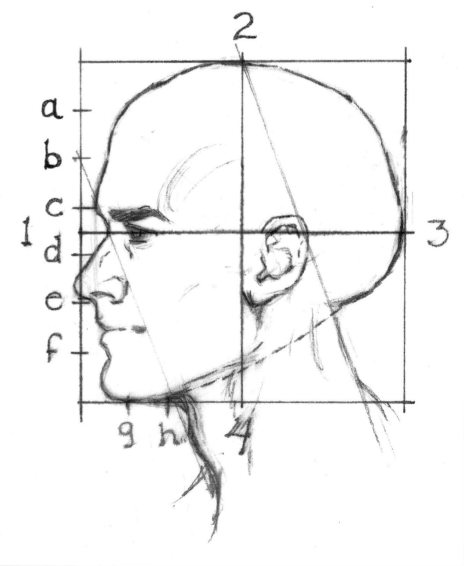

Step-by-Step: **Further Practice**

Now for some fun. Place tracing paper over the charted head you just drew and add hair, or a beard, a hooked nose, or a receding chin. Look at the variations in structure for a Black man, an Oriental, and a Native American that follow. No two heads are alike, but the charts will help you learn what to *look for* in the people around you and in models who pose for you. Draw twenty heads a day until you become fluent at this.

The classic Caucasian male.

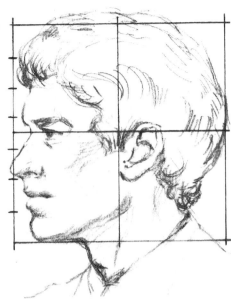

The same man with longer hair, a moustache, and a beard. *Warning:* A beard must be drawn with extreme care, or your man will resemble a dog!

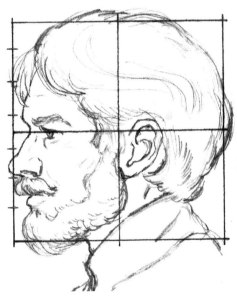

A Caucasian male at age eighty. His teeth are gone, so the lower part of his face has become shorter (as it is with an infant). The fatty tissue has disappeared, making the skin less firm and the bones under the skin more visible. Gravity has the greatest effect in aging all of us — eyelids, nose, cheeks, all are pulled downward. The spine is less erect and the head extends farther forward.

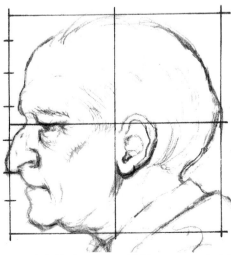

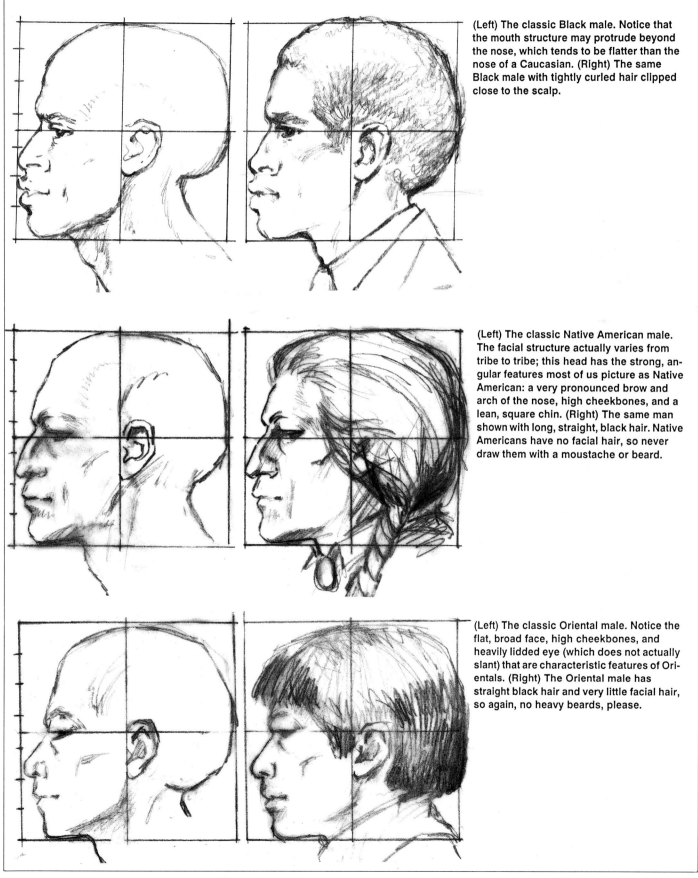

(Left) The classic Black male. Notice that the mouth structure may protrude beyond the nose, which tends to be flatter than the nose of a Caucasian. (Right) The same Black male with tightly curled hair clipped close to the scalp.

(Left) The classic Native American male. The facial structure actually varies from tribe to tribe; this head has the strong, angular features most of us picture as Native American: a very pronounced brow and arch of the nose, high cheekbones, and a lean, square chin. (Right) The same man shown with long, straight, black hair. Native Americans have no facial hair, so never draw them with a moustache or beard.

(Left) The classic Oriental male. Notice the flat, broad face, high cheekbones, and heavily lidded eye (which does not actually slant) that are characteristic features of Orientals. (Right) The Oriental male has straight black hair and very little facial hair, so again, no heavy beards, please.

Step-by-Step: **Drawing the Female Head in Profile**

Again we begin with a two-inch square divided into four one-inch squares. The process is much the same as for the male profile except that the forms are softer, so try using more curved lines than straight. The life-size head of a female of average height measures 8¼ inches from the tip of the nose to the back of skull, and 8¼ inches from the top of the skull to the bottom of the chin. Again, this charted female head is a more or less "ideal" classic Caucasian.

1. Place the eye on the halfway mark—the line would be through the center of the pupil if the eye were looking straight ahead. The front edge of the eyelid may be drawn approximately one-third of the distance from the left side of the square, *a* to *f*, to the center vertical line *2* to *4*.

2. After dividing the left edge of the two-inch square into seven parts, draw the brow and the skull projection at *c*. In females the eyebrow is often higher and more curved.

3. Put the base of the nose at *e*, halfway between the brow and the bottom of the chin.

4. The top of the ear is on a line with *c*, the bottom of the earlobe and base of the nose are at *e*, and the front of the ear is at center vertical line *2* to *4*.

5. Note that her forehead is much more curved than the male's. Draw this line from *c* curving to the top of the skull at *2*, around to the back of the head at *3*, still curving to a point level with *e*, the base of the nose.

6. Place the mouth between *e* and *f*.

7. Drop a curving chin line to *g*. Sketch a jawline from *g* to the base of the skull.

8. Since the female neck is more slender and often longer than the male neck, try drawing a slightly curved diagonal from *c* at the brow, back and down, so that the pit of the neck lines up under the earlobe.

9. Parallel to the line you've just drawn, draw a slightly curved diagonal from the top of the skull at *2*, touching the top of the ear to the base of the skull for a guide-line indicating the back of the neck.

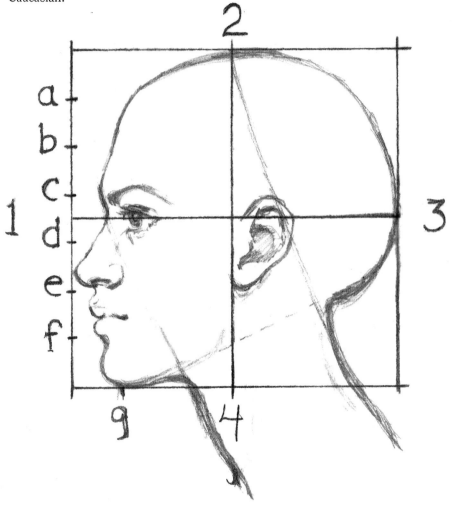

Step-by-Step: **Further Practice**

After making several charts, put tracing paper over the head, drawing the woman with some hair as shown in the two top drawings below. Change her hairstyle—maybe to your own. Note how these changes affect her age and personality. Try at least ten different looks. Draw her middle-aged, then make her eighty years old.

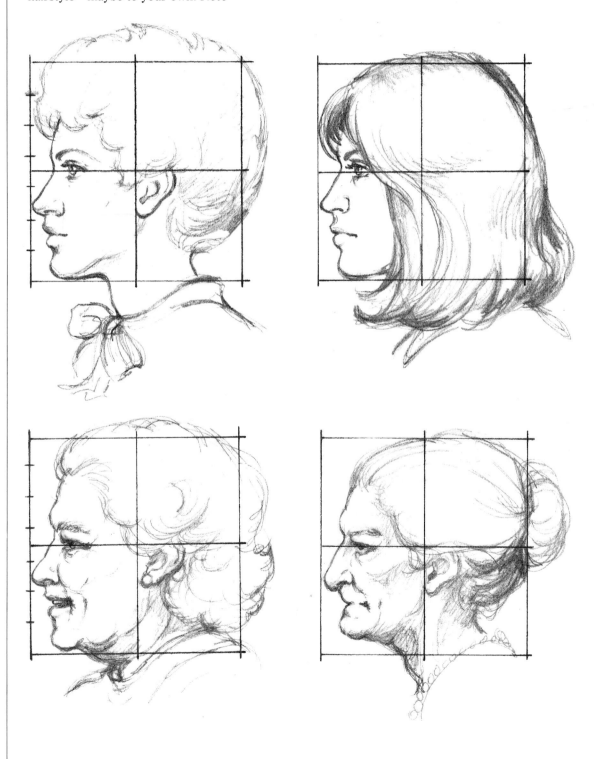

Study the features in the drawings on the previous page, then draw the woman as a Black, then an Oriental. Begin to really look at the heads of people around you. Remember, there is no substitute for thoughtful observation of life.

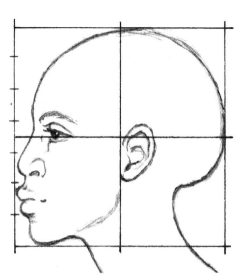 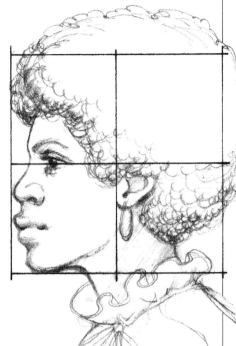

(Above) A classic Black female head. The mouth structure may project a bit more than the nose, which is slightly flat. The chin is very rounded. The brows are high and the eyes quite large. (Right) A modified Afro hairstyle and a collar are added.

A classic Oriental female head. Because the facial plane is slightly flatter than that of a Caucasian face, the bridge of the nose is less defined. The skin, not being pulled taut to cover a more projected nose bridge like that of the Caucasian face, forms the Oriental eyelid. The eye does not really slant, but in many instances, it lacks the extra fold of the Caucasian upper eyelid.

You'll seldom have an opportunity to paint the portrait of a woman in a geisha wig, but I wanted you to see the dramatic change this hair treatment makes.

Step-by-Step: **Drawing the Infant Head in Profile**

An infant's head is quite different from an adult's. The face itself (eyes, nose and mouth) takes up a relatively small area of the head, the face is much flatter, and there is virtually no chin.

The infant's face is sometimes nearly lost in fatty tissue. In profile, the cheeks can totally obscure the corners of the mouth. The distance from nose to chin is quite short, since there are no teeth. (This happens again in old age as the teeth are lost.) The eye appears very large in the tiny face because the eyeball is nearly the size of an adult's. Very little of the white of the eye is visible, but that which is observable is blue-white. The skull is sometimes flatter and longer rather than round. The infant usually doesn't have very much hair. You can try drawing the heads of babies of different races, but you'll find there are considerably fewer differences at this age.

1. Most babies have almost invisible eyebrows, but place a small eyebrow mark on the halfway line *1* to *3*.

2. Divide the lower half of the left edge of the square, at the face, into four segments.

3. Draw the eye at *a*, also a very shallow bridge of the nose. The eye is very round.

4. Make a small bump of a nose between *a* and *b*, and a projecting upper lip at *b*. Very often this upper lip protrudes even beyond the nose.

5. Pull way back and place a very tiny lower lip at *c*.

6. Add a round receding chin, very small, between *c* and *d*. A curving fold of fat rather than a jawline is evident here.

7. Place the ear, halfway back on the skull, from brow line *1* to *3* down as far as the base of the nose.

8. Add a very round skull curving from *1* up to *2* to *3*. At the back its base is on a level with *b*, the upper lip.

9. The infant's and child's head sits on a straight neck, but it is very short and not easily seen until the little one sits up at about six months. The head does not project forward as does the adult's.

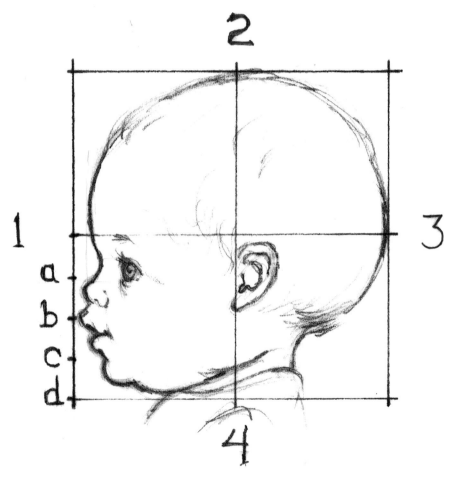

Step-by-Step: **Further Practice**

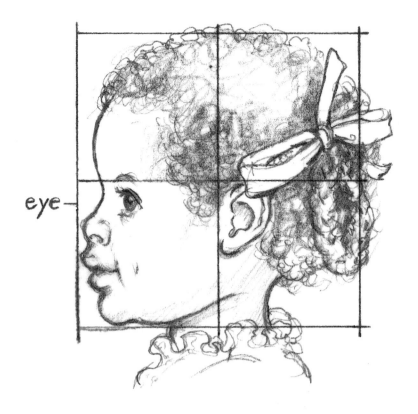

eye

The Child When the child is four or five, the face is still quite small in proportion to the entire head, but the eye has "moved up" from the infant proportion. This is because there is more mass in the lower quarter of the face — there are now upper and lower teeth and a jaw that has grown to accommodate them. This lengthens the facial mask. Study the illustration here and see if you can draw a child's head with similar features.

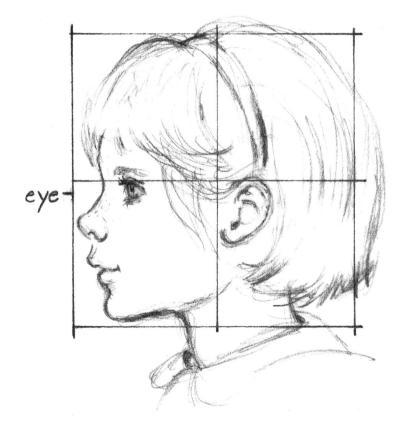

eye

The Preteen As the child matures, the eye "moves up" until it reaches the halfway line at adulthood. This child is eleven or twelve years of age. Baby fat has gone and is replaced by more clearly defined features.

It's quite difficult for an artist to get a child's age right at any stage of life, but from age eleven to fifteen this becomes a challenge to the best of us. Extra-careful observation is the key.

Step-by-Step: **Drawing Adult Heads, Frontal View**

The major difference between the frontal view and the profile view is that the entire head, seen from the front, is considerably more narrow. A male head, 9 inches high, is 6½ inches wide, with maximum width just above the ears. The vertical proportions do not differ from the previous profile diagrams, that is, the eyes are halfway down the head at horizontal line *1* to *3*, the base of the nose is halfway between *c* (the brow line) and *g* (the chin line).

A rule of thumb says the head (on the eyeline) is five eye-lengths across. The outer two eye-lengths are normally somewhat obscured by hair.

The corners of the mouth (when it's not smiling) often fall in a line directly beneath the pupils of the eyes. The neck of the athletic male is as wide as the jaw, while the adult female neck is often more slender.

To make your own charts, copy these proportions onto a larger piece of paper or place tracing paper over these drawings and copy the basic structural lines. Then fill in the squares with your own versions of these heads, working freehand from the instructions provided above.

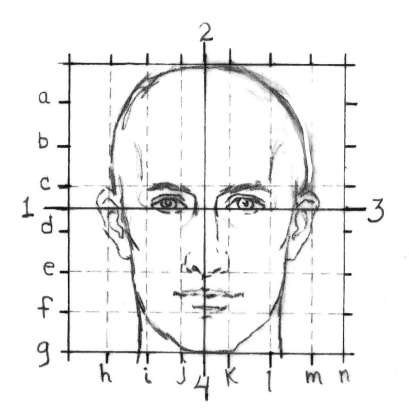

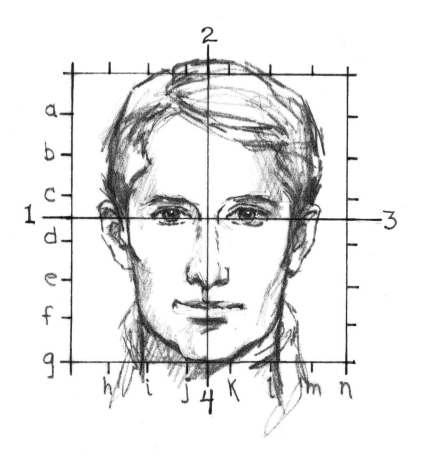

Step-by-Step: **Further Practice**

Using the diagrams you have made, give your male and female drawings hair and collars. Try several more with different physical characteristics. Vary the race, the age. Add beards or eyeglasses. Remember, glasses must sit on the *bridge* of the nose and inside the top of the ears. Look at candid photographs in newspapers and magazines for ideas; every person is unique.

Try ten profile views one day, ten front views another, giving yourself at least four days on each view until you can draw the diagrams comfortably and without strain. Later you'll need only the vertical and horizontal proportional lines as corrective checks in case you get into trouble on a head.

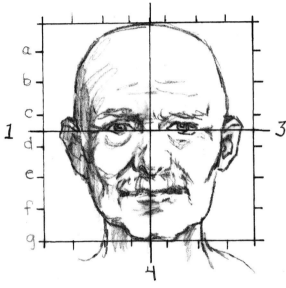

The sixty-year-old male.

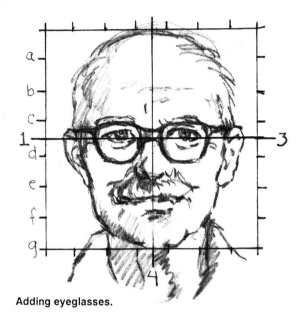

Adding eyeglasses.

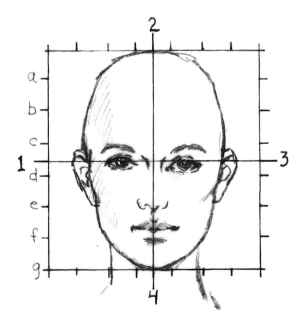

The adult female, front view.

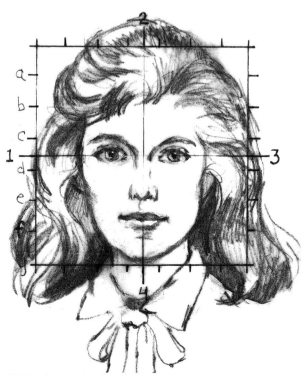

Adding hair and collar.

Step-by-Step: **Children's Proportions, Frontal View**

Children are not that different from adults. Just remember, the younger the child, the *lower* the eyeline. And the child's head is wider in relation to its length, giving the whole head a more round appearance. As the child grows older, the eyes move up to the halfway eyeline, and the face (along with the entire body) loses the baby fat, becoming less round and more elongated.

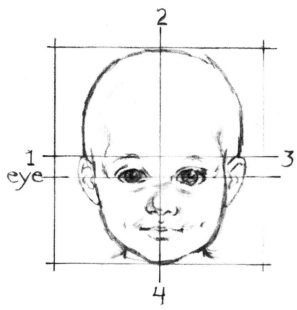

The toddler, front view.

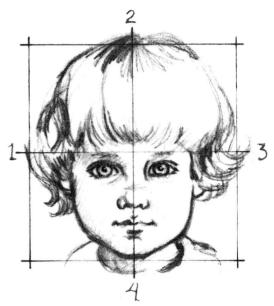

Toddler with hair and collar.

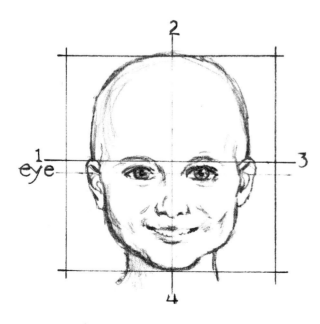

The six- to eight-year-old.

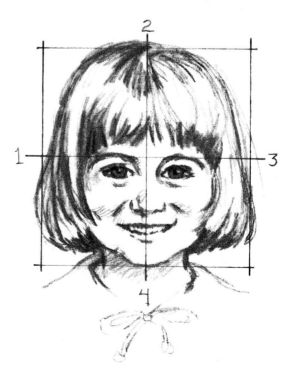

The six- to eight-year-old with hair and collar.

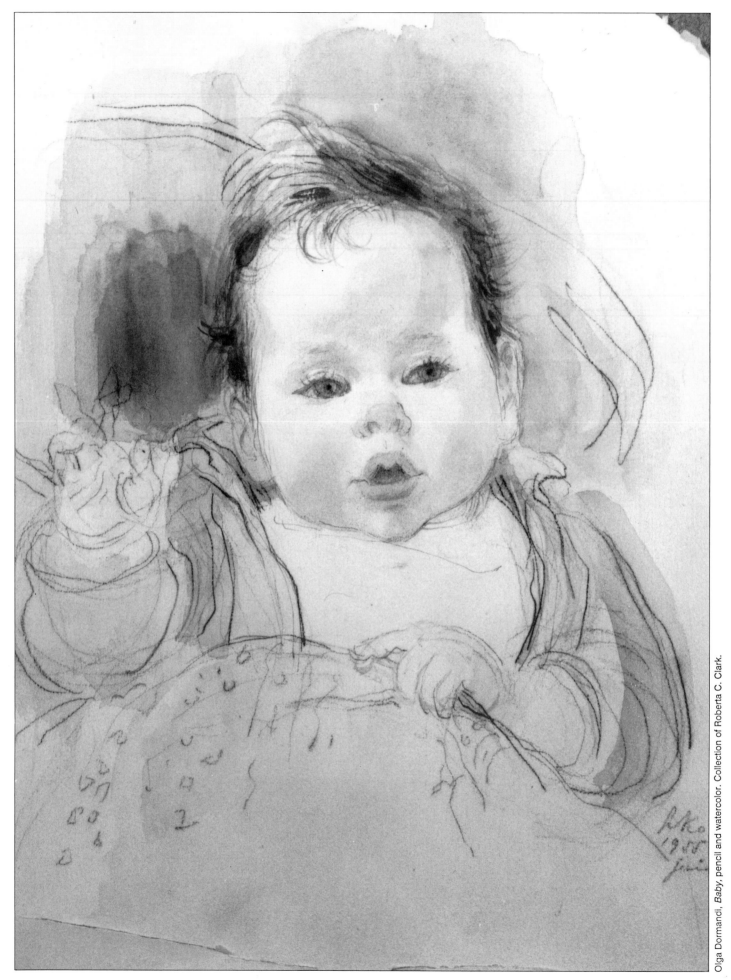

Olga Dormandi, *Baby*, pencil and watercolor. Collection of Roberta C. Clark.

DRAWING THE FEATURES

Every day of our lives we look at the eyes, noses, and mouths of our own faces and those of our companions. Indeed, we are so familiar with these features that in order to draw them we must step back and rediscover each one. To accomplish this we will try to reduce the eye, nose, mouth, and ear to their most basic components. In doing so, we will become more aware of their construction and form.

You may wonder why you will be asked, over and over again, to study your own face in a mirror. I have the best of reasons. The mirror studies that follow the description of each feature will help you become more observant. A fine portrait painter is sensitive to the most infinitesimal changes in shape and aspect of the facial features. The portraits you paint can only record what you've seen. *Seeing* is even more important than understanding color or knowing how to handle the brush. My most important obligation in writing this book is to help you to learn to see.

The Eyes

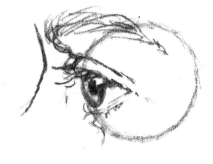

The eye is actually a ball that rests in an opening in the skull known as the orbital cavity. Held in place by muscles and ligaments, the eye is protected by eyelids. These folds of skin close over the ball. They are made up of soft tissue and conform easily to the spherical eyeball.

The eyelids have thickness, easily perceived when you study them. Because of this thickness, the upper lid casts a shadow upon the ball. At the edge of both upper and lower eyelids is a fringe of fine hairs, the eyelashes, which keep out dust particles and foreign matter and further protect the eyeball.

At the inner corner of the eye opening, near the nose and just over the tear duct, is a small pocket, which is pink inside. This inner corner of the eye is most often lower than the outer corner.

The colored part of the eye is the iris. Shadowed by the upper eyelid, it appears to be darker at the top. It is often shaded like an empty bowl.

The pupil in the center of the iris is black. It's actually an opening into the eyeball that admits light to the retina and enables us to see. The pupil grows larger in dim light, allowing more light to be admitted; in very bright light the pupil contracts to protect the retina (the light-sensitive membrane lining the inner eyeball).

The eyes move together—looking up, down, left, or right. And they always look wet and shiny because they are always bathed in tears.

The eyebrow follows the bone forming the upper edge of the orbital cavity. Where the light hits this bone, the brow appears lighter. This brow bone is called the *superciliary arch.*

The eyes are the very best indicators of mood, of emotion. As many have said, they are the "very windows of the soul."

Observing the Eyes

Begin your study of the eye by observing your own features in a mirror. That way you don't have to look for someone to pose, and you can study each feature as intently as you like without embarrassing your sitter.

Find a place in fairly good light where you can sit or stand. You may want to use your easel for this study. You'll also need a hand mirror for the profile views, unless you have a three-way mirror.

Move your head slowly to one side, then the other, and notice how the shape of the eye opening changes. Now, move your head up and back so you're looking down your nose at the mirror. See how much smaller the eyes look? Move your head down, chin on chest, and look up at your eyes in the mirror; now they look quite round.

Scrutinizing your eyes this closely you may find that one eye is larger, or higher, or has a droopier eyelid. This is quite normal—don't be alarmed. Not one face in a million is perfectly symmetrical. Indeed, your close observation of these deviations from the expected will give you your likeness. Generalizing the forms you see takes away character and personality from your portrait.

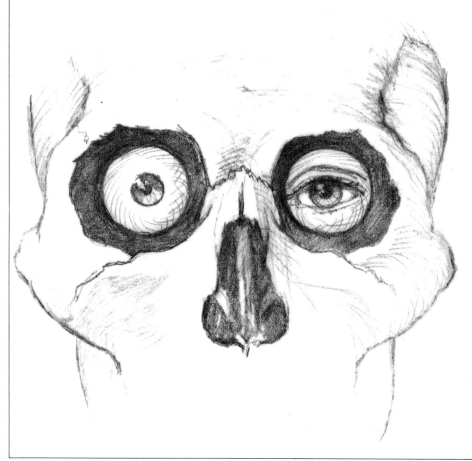

Step-by-Step: **Drawing the Eyes, Full Face**

You will need a soft pencil, drawing paper, and kneaded eraser for this study—and the mirror, of course.

1. Start with the sphere of the eye, lightly drawn. (Even though you can't see it, you know it's there.) Draw a second sphere for the other eye, leaving an eye's width between. (See the sketches at right.)

2. Draw the eyelids curving over the sphere as shown in the second sketch. Notice the lower lid has a different contour from the upper lid. And the upper lid casts a shadow upon the eyeball. Without this shadow, the eye will appear to be "popping"—too prominent.

 Now add the tearduct where the upper and lower eyelids intersect, next to the nose. Most often this corner is lower than the outer corner. Draw the fold line in the upper lid, and perhaps add some shadow as shown here to indicate the depression next to the bridge of the nose. Is there a fold line *under* the eye?

3. Draw the eyebrows. Remember the brow is made up of many small hairs; it's drawn with short strokes, not one continuous line. Lay in any shadows you see under the brow bone, and under the lower lid. Erase the eyeball circle line.

4. Put in the round, colored iris. If you open your eyes very wide, you'll see the entire circle; without stretching your eyes open, either the top of the iris will be covered by the upper eyelid or the bottom part by the lower eyelid, or, most likely, both the top and the bottom by both lids. It's very unusual to see the entire iris. Look carefully for the shiny white highlight, and leave that tiny area of the paper white (or you can lift it out later with the eraser).

 Now add the black pupil in the center of the iris. Make this very dark.

 Study the right eye. Add the eyelashes *only where you see them.* Check the alignment of the two pupils by laying your pencil horizontally across them, making sure you are holding it straight and not tilted. (This method is indispensable no matter what medium you're using to draw or paint eyes. It also works well on aligning the ears, and straightening up the mouth or the nostrils.)

Finishing Up With one last critical look, check your work by looking at your *drawing* in the mirror. Looking at your artwork in a mirror is a foolproof way to spot errors. In this instance, you could clearly see if one eye is larger, or lower, or out of kilter in any way. Correct any errors you find. Add whatever accents you see in the eyes that will bring your drawing to life. For example, you may wish to add an extra dark shadow under the upper lid. Or darken the upper third of the iris, which adds considerable depth to the eyes. Or you may want to add small dots of extreme dark or extreme light to add the "snap" that gives the eyes life.

Don't you really love drawing eyes? Isn't it exciting and challenging to make them look as if they might blink, or to have them convey mood? As you draw other people's eyes, try to get the age group right. For example, glamorous eyes with long sweeping eyelashes would be inappropriate on a child. Can you show wisdom in the eyes of someone who has lived quite a long time? Some eyes really do sparkle and dance. Can you portray this effect?

Incidentally, if the sitter is posed so that the eyes are looking at the artist, and the artist has painted the eyes as properly focused, the resulting portrait image will appear to be looking at anyone viewing the portrait and the painted eyes will "follow you around the room," a phenomenon that never ceases to amaze the viewer.

It's safe to say you will never be bored drawing eyes, for everyone's eyes are unique. The variety is infinite.

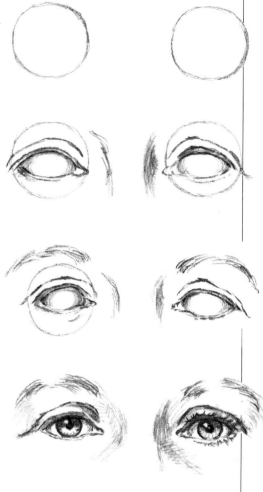

Step-by-Step: **Drawing Profile Eyes**

The only way you can study your own eye in profile is to look at it in a second mirror, such as at a hand mirror reflecting your image from a wall mirror. (You can also use a three-way mirror if you have one.) This may seem a little cumbersome, but the information gained from this study is well worth it.

Hint: Try drawing some eyes in profile by observing other people. These are easier than full-face eyes, for they don't have to be looking at you. If you keep at this, you'll soon find you can do an eye quite quickly!

1. Begin with the lightly drawn sphere. Of course you can see only one eye when looking at the eyes in profile, for the other eye is hidden behind the nose, on the other side of the head.

 Draw the curve of the upper eyelid, then the lower lid. You will be unable to see the tearduct pocket.

2. Add the eyebrow, then the shadow under the brow, if there is one, and the shadow under the lower lid.

 Study the iris. You will see that it is no longer round from this angle, but is a flattened disk shape, and a part of it will be hidden by the eyelid. The highlight is even smaller in this view; study it carefully and try to leave it the white of the paper when coloring in the iris. If you can't manage this, pick it out with your kneaded eraser.

 Now draw the pupil, which is also a flattened disk shape, very dark. The darker you make the area surrounding the highlight, the brighter the highlight will appear. Put in the eyelashes, which are much more prominent in the profile view. Then add the accents.

 Finally, erase the lines indicating the sphere that are still visible, and there you have it!

Step-by-Step: **Drawing the Eyes, Three-Quarter View**

This view requires even more careful observation than the full face or the profile. Most of the heads you will paint will be in a three-quarter view as this angle appears most natural and least posed. Look in a mirror and draw your own eyes, but each time you look, be sure your head is in *precisely* the same position as before. A half-inch turn to the right or left changes the perspective of the eyes.

1. Draw the two spheres and draw the eyelids over the spheres. Immediately you'll see why this view needs careful observation: the left eye is *very* different from the right. Coloring in the irises should help with the eyelids. (Try to leave the highlight white.) Add the fold line in the upper lid with care. Then the tear duct. See how the inner corner of the eye farthest away from you is partially hidden by the bridge of the nose. You may not even see the tear duct of that eye.

2. Add the pupils, very black. Leave the highlights the white of the paper or lift them with an eraser. Add the eyelashes only where you see them. Draw in the eyebrows. Then look for shadows — where? Usually there are shadows on both sides of the bridge of the nose at the inner corner of the eye, but don't add them unless you see them. Is there shadow under the lower lid, and at the outer corner of the eyes?

 Erase the sphere where it is still visible. Incidentally, these eyes are my own, drawn while I studied them in a mirror.

Exercise: Draw as many pairs of eyes as you can from life, magazines, and photographs, every day for a month. This effort will be of enormous benefit to you. I believe it's safe to say that the success of your portraits depends upon your finesse in drawing and painting eyes.

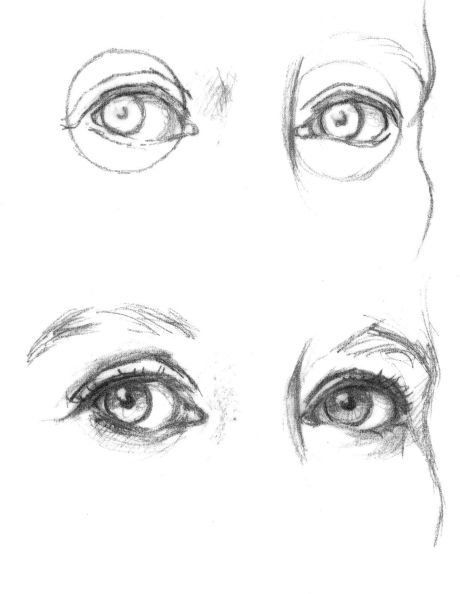

Hint: The three-quarter view is less static than the full face or profile. More movement is indicated because the head is facing one way but the eyes are looking another.

Variations in Eyes

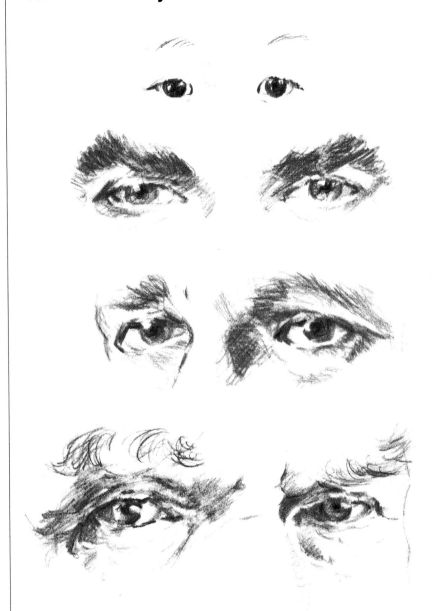

Compare the drawings of the eyes above, from the simplicity of the Oriental infant's eyes to those of a 35-year-old man, a 50-year-old man, and a 65-year-old man. The open gaze of a baby is quite different from the complex scrutiny of a man who has seen much and met many challenges.

These drawings are not included to show any drawing skill I might have, but to prove there actually is *no* formula for drawing eyes with meaning and intensity. Your ability to draw eyes will come from the hundreds and thousands of eyes you'll draw in the future, particularly from all you observe as you do these studies.

Study and analyze these drawings of eyes. To see them more abstractly,

turn this book upside down. This will make you even more aware that it's the *texture* that makes the eyebrows, that it's the *broken and uneven line* that gives action and structure to the eyes, that it is the placing of the very darkest dark next to the brightest white—*the accents*—that gives the eyes sparkle and life. Look at the page again right side up and you'll see that it's the way the dark pupils are placed that makes the two eyes focus. Finally, look at the way other artists in this book have handled eyes. John Singer Sargent and Edgar Degas—each has treated eyes differently. Every artist has his or her own way, and you will too. You can learn from every portrait you see.

Common Errors: Drawing Eyes

Making all edges too hard. Keep the edges of the eyelids soft, saving crisp touches for accents. Keep the edge of the iris against the white of the eye relatively soft. Breaking the line of the lids helps add life to the portrait.

Putting in too many eyelashes or making them too distinct. Use restraint when indicating eyelashes. Nothing cheapens your work like having too many eyelashes lined up around the eyes like spidery legs. Remember, too, eyelashes are seen in perspective, with some coming directly at you.

Making eyelashes too dark. These can make a child appear too old, too sophisticated, and very unchildlike, as if made up with mascara.

Making the highlights in the eyes too white or too large. Placing the highlight in the eye is certainly the most fun of painting the entire portrait, but if you don't restrain yourself here you diminish the quality of your work considerably. Sometimes you may see a highlight in only one eye—if so, paint it that way. Also, try to decide which eye has the most dominant highlight—is one eye larger? Brighter?

Painting the whites of the eyes too white. Careful observation of values is important here; squint very hard to help you see them clearly. The next time you're in a museum, hold a piece of white paper in front of a favorite portrait; you will see instantly how far from white the eyeballs are!

The Nose

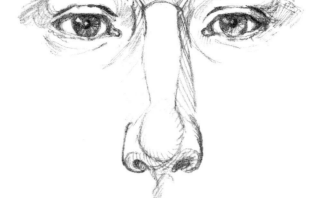

Students seem to have a great deal of trouble with the nose, probably because it projects. The easiest way to draw a nose is the way children do, with two dots indicating the nostrils:

Another simple way is to use a sort of seagull-shaped curving line:

However, these marks give us no information about construction of the nose, which we must understand before we can draw or paint this feature. The following facts will help you.

The nose is always centered between the eyes and is narrowest at the top, or bridge, where eyeglasses rest.

The nose is a vertical form, never horizontal, and is normally straight from top to bottom. If the nose has been injured or broken, it may veer slightly to the right or left.

There are two openings at the base of the nose on the bottom receding plane—the nostrils. Very often these are not clearly seen from the front view, and sometimes not even from the side view.

The nose has far less mobility than the eyes or the mouth. The nostrils can dilate, and the nose can wrinkle when a foul smell is noticed, or when someone is talking baby talk to an infant, but these movements are fairly infrequent and rarely occur in portraits. The only other way the nose changes is when the subject is smiling. Then it appears wider as the nostrils are stretched laterally.

Observing the Nose

The nose begins where it meets the forehead and brow in an inverted wedge shape between the eyes and at the level of the eyebrows. Narrowing at the bridge, it then widens as it travels down the face toward the bulbous tip. On either side of the tip, the nose flares out, forming covering for the nostrils. The underplane recedes—hard to indicate from the front—and progresses to the indentation between the nose and the upper lip.

This a good time to talk about the wedge-shaped area where the nose meets the forehead and brows, called the keystone area (see drawing at top). There is a delicate shadow here and a light just under it where the bridge of the nose is indented, the spot where eyeglasses rest when they are worn. Experienced portrait painters work out this wedge and bridge area with extreme care, while beginners overlook this area entirely.

Nostrils are dark, but don't indicate them as black holes. Just incorporate them into the shadow area beneath the nose. When working in color, *always* make the nostrils warm, a reddish hue.

On the drawing below you'll see that beneath the skin and the muscle, the nasal bone extends downward from the frontal (forehead) bone of the skull about a third of the length of the nose, and ends at the nasal cavity, an opening in the skull.

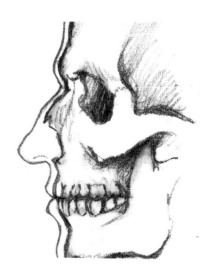

The nose itself is made of cartilage. This may not seem important to the artist, since the area where the nasal bone stops and the cartilage continues cannot be seen. However, when you *really* look at this area, you will perceive the slightest shadow *across* the form at this juncture. Study the drawings at left. Notice that if there is a bump in the nose, it is usually at this point where the bony structure comes to an end. You really need this change in plane to express the individuality and character of the nose on the portrait you are painting. When drawing the nose, break your highlight here.

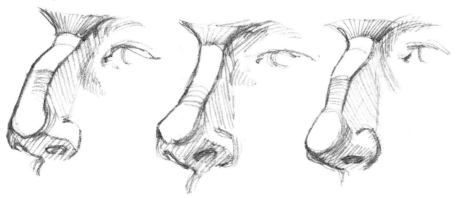

Step-by-Step: **Drawing the Nose, Full Face**

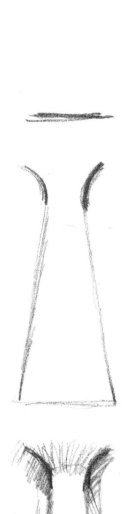

You'll need a soft pencil, your sketch paper, a kneaded eraser, and a mirror for these exercises.

1. Looking in the mirror, study your nose and try to see it as a triangular block projecting from the facial surface. This form has a top plane, two side planes, and an underplane. You can't really *see* a line where the side plane of the nose meets and changes to the front plane of the cheek, but it helps to imagine such a line. It's easier to *feel* it than to see it. Press hard enough to feel the side planes of your nose, then the cheeks. (Also feel the higher cheekbones and the edges of the eyesockets all around your eyes.)

2. Refer to the top drawing at left and start to draw. Begin with the deep indentations on either side of the bridge of the nose, near the inner corners of the eyes. Then make a mark at the base of the nose. Whenever you draw any form, always lightly indicate its boundaries first. You can't just begin at one end and hope that all will come out right at the finish.

3. Lightly draw the triangular shape of the nose as shown in the middle left drawing. Thinking of the nose form as a solid block, draw the side plane on the shadow side, the side plane on the lighter side, and the top plane. It's important that you begin your noses this way, even if you do not actually *see* all three of these planes. It is important that you understand this structure. The lines defining the planes can always be erased later.

4. Now draw the fleshy rounded ball of the nose, as shown in the bottom left drawing, with rounded lines to express its more bulbous shape. Then the flaring wing-like shapes on either side.

5. Now indicate the bottom plane, the underside of our solid triangular block. Draw a light line where you think the side plane of the wing-forms turn under to become the bottom plane, and also where you see the top and front of the ball of the nose become the underside—and you're done!

6. The nose casts a shadow on the cheek or the area between the nose and the upper lip—or both. Do you see any cast shadows? Add them, but don't go too dark, or they'll look like holes. Look for the outer shape of the cast shadow; it will help define the shape of the form it's falling on.

 Do you also see the reflected light, bouncing up onto the bottom plane? Lighten your shadow area there just enough. Remember the reflected light can *never* be as light as your light area, or the solid form of the nose which you have worked so hard to achieve will just fall apart.

7. Clean up your drawing now by eliminating your construction lines, unless you like them there. Add small dark accents where your drawing needs more definition. Round off forms where necessary. Lift out the highlights: (1) at the bridge of the nose just below the keystone shadow; (2) on the bony part of the nose, a third or halfway down (not every nose has this highlight); and (3) the shine on the tip of the nose—the brightest, most obvious highlight. You might minimize this highlight on a beautiful woman; it could be a dashing slash on a man, second in importance and vigor only to the bright highlights in the eyes. On children this highlight is usually round and sharp. The proper placement and brilliance of this highlight will accomplish many things for your portrait. Look at John Singer Sargent's portraits for highlights; he was the master of them all! (See page 165.)

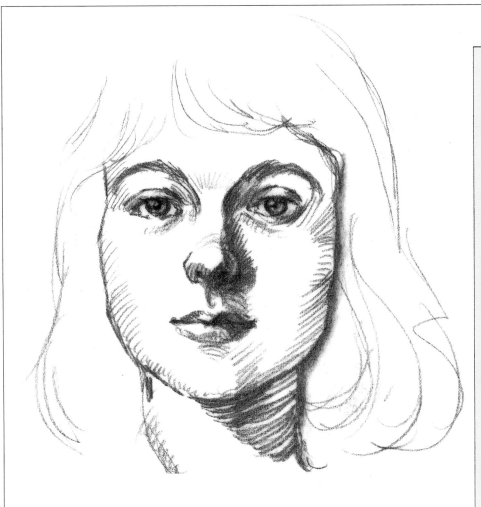

Common Errors: Drawing the Nose

Running a highlight down the entire length of the nose. You will never see a highlight running from the nose bridge to the tip, straight, all the way down. So if you see one on a drawing or painting you'll know the artist wasn't really sensitive to his task, or the work was a highly stylized portrait.

Not showing a delineation at the point where the bridge of the nose meets the forehead. You will never see a nose come straight down from the forehead (the frontal bone) without a change in plane. There is *always* an indentation at the nose bridge. You don't always have to note this keystone underplane with shadow; you can indicate it with a change in color temperature.

Making black holes for nostrils. Remember, your sitter is *alive.* Just under that skin is a capillary system with blood flowing constantly. Remember that all the openings in the head are *warm.* In paint, mix some reds into the nostril color. In drawing, don't make these openings so black that they appear too prominent. The nostrils in the portrait become part of the shadow under the nose.

Making the shadow under the nose on the area above the upper lip, or beside the nose on to the cheek, too solid or too dark. Shadows should be luminous and transparent, so these shadows must be underplayed. If they are very dark on your drawing or painting, they appear to create a "hole" in the face and destroy the form.

Cast shadow from the nose, hitting the lip. If you ever see the shadow under the nose reaching down as far as the lip, change the lighting. This shadow pattern is most unattractive. The younger the sitter, the lighter the shadow under the nose.

Making the Nose Project There are three ways to get the nose to project:

1. Make the shadows on the side plane and the underplane of the nose darker than the shadow on the side plane of the face, going back toward the ear.

2. Draw the tip of the nose crisply, not softly. *(Hard edges project!)*

3. Make the highlight on the tip of the nose crisp and sharp.

Making the Nose Less Noticeable
Conversely, to subdue a too-prominent nose you can de-emphasize it as follows:

1. Keep the shadows on the side plane and the underplane of the nose fairly light, or mid-value. Also minimize the shadows cast by the nose.

2. Keep descriptive lines soft.

3. Play down the highlight on the tip of the nose.

Step-by-Step: **Drawing the Profile Nose**

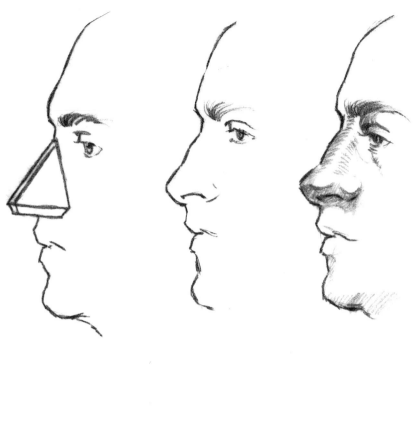

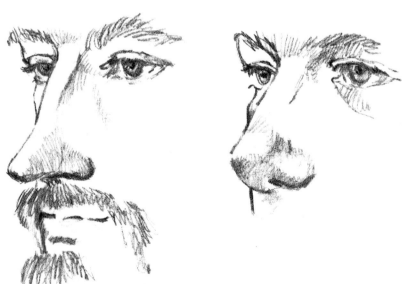

Study your nose from the side in a second mirror. Now block it in as a triangular shape projecting from the facial surface. Then start at the top with the keystone area between the brows. Look for the curved indentation at the bridge. The nose then projects from the bridge, rounds off at the tip, and recedes to the area above the upper lip. Add the curved wing growing into the cheek, then the nostril.

This appears easier than drawing the nose in the front view, but this is only partly true. While you can more easily perceive the shape in profile and therefore more easily draw it, it's more difficult to make it appear solid. This is one of the problems you'll encounter in drawing any of the features, and even the head itself: The drawing will look flat in profile, like a silhouette.

Making the Nose Project In order to give a feeling of solid form to the profile nose, you can shadow the underplane. Add a cast shadow from the nose form onto the upper lip area. Put in the halftone on the top plane and on the side plane of the nose, leaving the lights and highlights as white paper.

One way to avoid this flat appearance is to turn your head just enough to see the eyelashes behind the nose. *Now* you can draw the nose more solidly and, incidentally, the mouth as well. Follow the same order of activity as in the "flat" profile above: draw the keystone area first, then the indentation at the bridge of the nose. As you move down the nose, there is your top plane, the front plane at the tip, and the underplane. Do include the lines dividing each plane, to indicate your understanding of the division between these planes and the side plane. On the side plane, draw the curved wing over the nostril, then the nostril itself, if it's visible. Look at the illustration. Don't you agree that these noses look more solid?

Step-by-Step: **Drawing the Nose, Three-Quarter View**

1. Study your nose in the mirror in a three-quarter view—meaning somewhere between the full face and the profile. The triangular block shape works for this view too; because the block is in perspective, the nostril on the far side is only partially seen, or suggested.

 Slight changes in the view of the head can easily throw you off, and you'll be frustrated knowing your drawing isn't right without really knowing why. The drawing at right shows how changing the head's position changes the relationships of the features.

 Each time you look up from your drawing to study the nose, make sure you see the nose at *precisely* the same angle as before. You can check the angle by taking careful note of how much of the cheek you can see beyond the nose.

2. Lightly indicate the angle of the nose. If it's hard to determine, hold your pencil up and align it with the angle of the nose in the mirror, then place your pencil carefully on the paper at that same angle. Starting at the keystone area between the brows, block in the top plane, the side plane nearest you, and any suggestion of the far side plane that you see. If you don't see any, leave that plane out.

3. Draw the wing area covering the nostril. Define the ball or rounded area, and the slight shadow where the ball meets the bridge. Is there shadow on the side plane?

4. Is there a front plane at the tip of the nose? If so, indicate the underplane as the nose recedes to the facial plane. Then draw the nostril.

5. Pick out the highlights on the bridge area, the bony area, and the main highlight on the ball.

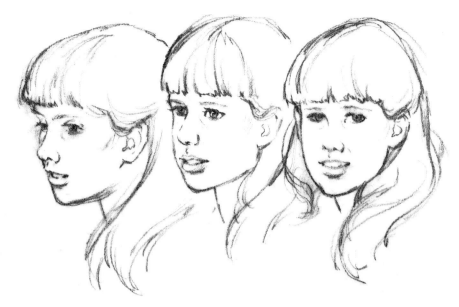

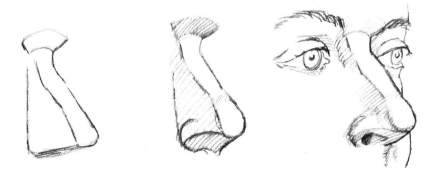

The Mouth

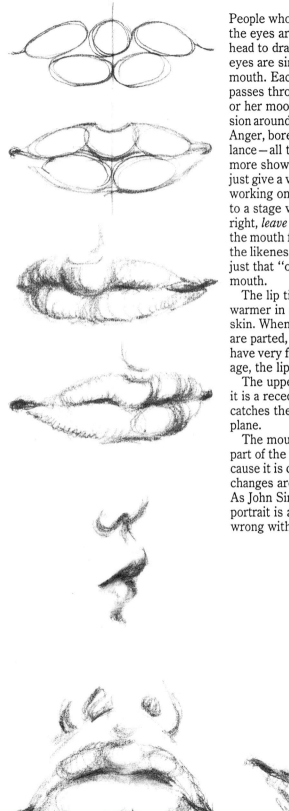

People who are not artists believe that the eyes are the hardest part of the head to draw, but, in my opinion, the eyes are simple compared to the mouth. Each time a new thought passes through your sitter's mind his or her mood changes, and the expression around the mouth changes as well. Anger, boredom, fatigue, disdain, petulance—all these feelings and a million more show around the mouth. Let me just give a word of advice: When you're working on your portrait and you get to a stage where the mouth is just right, *leave it alone!* Don't go back to the mouth for any reason. You can lose the likeness in a split second by adding just that "one more touch" to the mouth.

The lip tissue is darker in value and warmer in color than the surrounding skin. When the mouth is open and lips are parted, we see the teeth. Infants have very full, soft, rounded lips. In old age, the lips become thinner.

The upper lip is often in shadow, as it is a receding plane. The lower lip catches the light, as it is a projecting plane.

The mouth is the most challenging part of the portrait for the artist because it is constantly changing, but the changes are usually extremely subtle. As John Singer Sargent once said, "A portrait is a picture with something wrong with the mouth."

Observing the Mouth

When drawing the mouth, remember that the upper lip is made up of three parts, the lower lip of two, as shown in the drawings at top left. The line between the upper and lower lip should be broken, varied in weight and intensity, to avoid a strained expression.

In every part of the portrait you want to give the illusion that the image *might* move. Nowhere is this more desirable than the mouth. We must be extremely careful not to draw firm dark lines *around* or *between* the lips. The edges must be drawn or painted softly, particularly on women and children.

Note the way the corners of the mouth tuck into the adjoining cheeks. Pay a great deal of attention to these corners. Do they go up? Down? How dark are they? If you paint them *too* dark, the mouth will appear very tight.

In a small child the upper lip is frequently much larger and more protruding than the very small lower lip, for the lower jaw is undeveloped.

Study your mouth in a hand mirror. See how soft the lip tissue appears. The center of the upper lip projects, and the corners really recede as they go back into the cheeks. Turn your head slowly to one side. As you approach a three-quarter view, the far corner of the mouth tucks in and disappears. Turn slowly to the other side; watch as the other corner disappears.

Now raise your chin, putting your head back. See how the mouth curves around the teeth. The corners of your mouth point down in this perspective. Try smiling. What happens then?

Put your chin down on your chest and notice how the mouth curves around the teeth. The corners go up now; they go up even more when you smile. Throw your head back and look up at your mouth. The lower lip appears thinner than the upper lip. Conversely, when your chin is down on your chest and you are looking down on your mouth, the upper lip appears thinner than the lower lip.

Step-by-Step: **Drawing the Mouth, Full Face and In Profile**

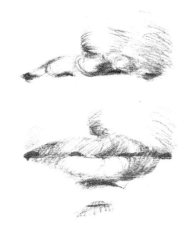

1. Studying your mouth in a mirror, indicate with a light line where you want the mouth to be on your paper. Look first for the corners of the mouth and place them.

2. The line between the lips comes next. Try not to draw this as one continuous line, but break it somewhere. This little break softens the mouth and prevents a tense expression. The viewer will mentally complete the line for you.

3. Now form the upper lip, developing it from the three oval parts. The light coming from the upper left or upper right throws the top lip into shadow. Add this tone.

4. While you're working on the upper lip, note the vertical indentation from the nose down to the lip and the shadow on the plane slanting back toward the cheek. If you're a man, you'll have facial hair growing in this area, which will tend to darken this part of the face.

5. Now look for and place the shadow under the lower lip as it travels down to the chin. Squint hard and study your mouth. Do you need to add tone to the lips? Perhaps to delineate the form of the lower lip? A woman wearing lipstick may need to add tone; a man might leave the lips as is.

Look hard for the highlight on the lower lip. Leave it the white of the paper, or lift it out with your eraser. Put in the dark accents you see in the corners of the mouth or between the lips. Tuck the corners of the mouth in well.

Try not to draw lines around the lips. The value difference between the lip tissue and the surrounding skin is hardly discernible in a black and white drawing.

1. Now let's try drawing the mouth in profile. Holding a mirror at the side of your face and looking at the reflection of your mouth in a second mirror, block in the mouth by first indicating the angle of the line between the lips.

2. Block in, in a straight line, the angle of projection of your lips. Is the upper lip protruding more—or the lower?

3. Tuck in the corner of the mouth.

4. Darken the upper lip if it appears to be in shadow.

5. Add the shadow under the lower lip and at the corner of the mouth. Keep the edges soft where the shadow blends into the light. Is the lower lip darker than the skin surrounding it? Add this tone if you see it. (Ladies, remove your lipstick for

this problem.) Now, with your eraser, pick out the highlight where you see it. You'll find the mouth is there without lines circumscribing it.

Step-by-Step: **Drawing the Mouth, Three-Quarter View**

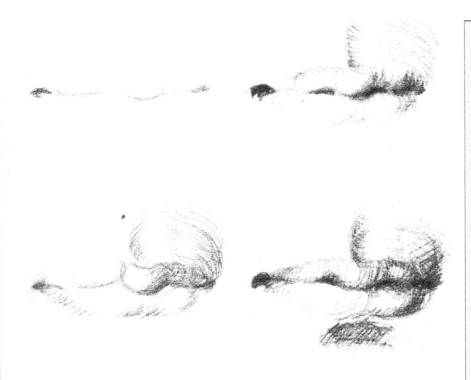

1. Study your mouth in the mirror. Keeping your lines soft, draw the line between the lips, and break it somewhere.

2. Lightly block in the upper lip by drawing the three ovals. Squint hard. Where do you see shadow? In the vertical indentation between the nose and the upper lip? On the shadow side of the lips from the center to the far corner of the mouth?

3. Tuck in the corners of the mouth. On the far side, the side turned away from you, the corner may not be visible at all. Don't put it in if you don't see it!

4. Add the shadow under the lower lip. Is the upper lip in shadow? Should the corners of the mouth be accented with darks? If the lips are darker than the surrounding skin tone, darken them. Now lift out the highlight with your eraser.

Common Errors: Drawing the Mouth

Handling the mouth too heavily. Use a very light touch on any mouth. To avoid making the mouth look weak, search out small points where you can place an accent, such as the corners of the mouth, under the lower lip, or on the line between the lips. Very often, these accents in and around the mouth will produce the likeness you want. Above all, do *not* draw lines around the lips.

Making the teeth too white, so they appear to protrude. On the other hand, if the teeth are too dark they'll appear to be discolored or decayed. And too-strong lines between the teeth will also look like decay or spaces between teeth.

Making the highlight on the mouth too glossy. This will diminish the character of your portrait because it's too distracting.

Handling Smiles and Teeth

Perhaps this is a good time to talk about teeth, while we are discussing the mouth. You probably didn't think you would be painting teeth! However, many people don't look natural with their mouths closed, and the teeth are an essential part of their likeness.

Just as the mouth curves with the front of the face, the teeth follow this same curve. The two front teeth are at least an inch ahead of the chewing molars.

Study the variety of mouths on this page. Try to see the teeth as a mass, not as separate bits like kernels on an ear of corn. Tuck the corners of this dental mass into the corners of the mouth well (see sketches below).

If you delineate the crevices between individual teeth, they will appear too prominent, as if the sitter had bad teeth and was ready for the dentist. The best way to indicate the individual teeth is to vary the color or the value *ever so slightly,* so as not to destroy the illusion of the teeth as one mass.

Look for the bottom edge design of the upper teeth. This line is often the key to an exact likeness (see sketches at bottom and at far right).

If the mouth is open, as it must be if we are to view the teeth, the upper lip will cast a shadow on the upper teeth.

Be careful not to draw it as a continuous line across the teeth. Better to indicate the fact that the upper lip overhangs the teeth by painting very subtle marks within the shadow to show the divisions between the teeth, but so subtle that the observer is hardly even aware of them.

Occasionally when having trouble getting a really good likeness, I've found I was ignoring the *lower* teeth. These lower teeth show more frequently than you'd expect when your subject is speaking or smiling. Start carefully observing the mouths of your friends and family when they're talking with you—and watch for their lower teeth.

Notice that the mouths depicted here are drawn with curving lines, expressing the full rounded forms of the lips. These curves describe protruding forms.

With a pencil, practice drawing all the mouths we've looked at so far in this chapter. Use curving lines, keeping some edges soft and placing dark accents where they really count. Then practice drawing mouths from magazine photographs. Remember, the more mouths you draw, the more confident you will become in your ability to portray them.

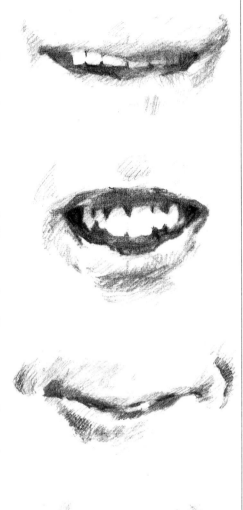

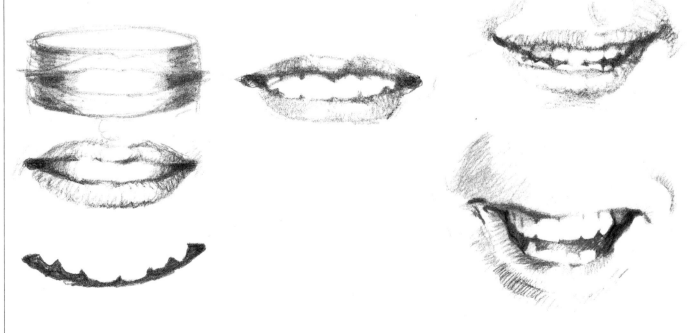

Step-by-Step: **Drawing the Ear, Full Face**

Students think ears are more difficult to draw than they really are. Some dedicated observation will eliminate this fear. Whether ears are quite flat or protrude, it's convenient to think of them as flat oval disks set at the side of the head. The ear is made up of cartilage, not bone, and has virtually no movement, so it doesn't change as one's expression changes. On an adult, the ear extends in a vertical shape from the brow line to the base-of-the-nose line.

In profile, the ear begins at the halfway mark between the front and the back of the head and extends toward the back. It also slants backward slightly, sometimes paralleling the line of the nose.

The inner line around the top of the ear seldom follows the outer shape exactly. Don't forget that both ears usually line up with each other and are seen in perspective when the head is tilted.

Observing the Ears

Oddly enough, although ears usually don't contribute very much to the likeness, when they're incorrectly placed they can cause you a great deal of trouble. And it's a very subtle kind of trouble, for no one is expecting ears to matter much. The face can be perfect, the ears beautifully drawn, but you'll sense there is something wrong. For students, the biggest problem seems to be aligning the ears with the eyebrow line and the base-of-the-nose line. Make sure you follow the curving eyebrow line when the head is tilting and hang the ears from that. Like the mouth, when the head is tilted back, the ears appear to be lower; head tilted forward, the ears appear higher.

Before you start to draw, sit up very straight, holding your head absolutely erect, and look in a mirror. Envision an imaginary line at the top of the ears and another at the bottom of the ears extending across the face. As you learned from the chapter on the proportions of the head, we have a rule of thumb that tells us the top of the ear usually lines up with the eyebrow, and the bottom with the base of the nose. But *your* ears may be positioned differently; look hard and decide.

Now tilt your head to the right or left and try to imagine the line across the bottom of the ears. It is *much* more difficult to get the ears properly placed when the head isn't posed straight up.

You will need a pencil, drawing paper, kneaded eraser, and mirror for this exercise.

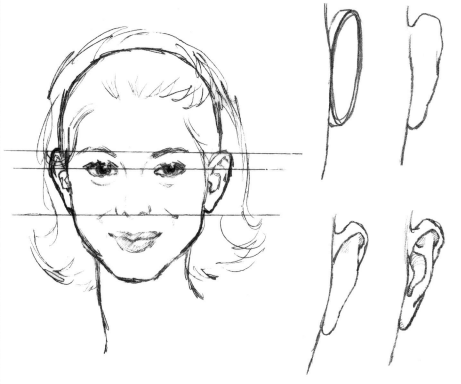

1. Block in the full-face diagram of the head using a light line to position the ears, top and bottom, where you see them.

2. Think of the ear as a flat oval disk and begin drawing your ears with that form on both sides of the head.
 Now refine the outer shape of the disks into the actual shape of your ear, as shown at near left.

3. Add the inner line curving around the top to form the rim or fold, called the helix, as shown at far left. Now, as shown at near left, define the bowl-like indentation of the ear and the small flap at the lower area. Draw the small flap at the front of the ear opening.
 Follow this procedure for both ears, and be sure to do both ears at one sitting. Does your hair cover part of your ears? Also, when you smile, do your cheeks cover part of your ears?

Step-by-Step: **Drawing the Profile Ear**

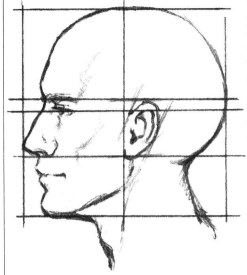

To draw your ear for this exercise, you'll need the two mirrors used for the profile view of the eye. As you sit up straight with your head erect, does the top of your ear line up with your eyebrow? Your eye? You will never get a good likeness in a profile if the ear is not correctly aligned with the other features, but many students don't realize this.

1. Draw a square profile diagram of the head as you learned in Chapter 1 and lightly position the ear as indicated (left). Study *your* ear and draw it where you see it. Does it align with the ear you just sketched?

2. Draw light lines indicating the top, bottom, front, and back of the ear (see the sketch below left). Then begin with the oval disk, slanting the top slightly toward the back of the head. Now refine the outer shape of the ear, top to bottom, as shown in the center illustration below.

3. Add the inner line inside the top of the oval as shown below right. Form the fold (the helix), and carry it down to the lobe.

4. Draw in the circular line describing the deep bowl; follow it down to the two quite rigid flaps which protect the ear opening—one at the lower back, one at the front toward the face. Add shadows and highlights. Now turn your head and draw your other ear. It is a different experience, drawing an ear from the opposite direction.

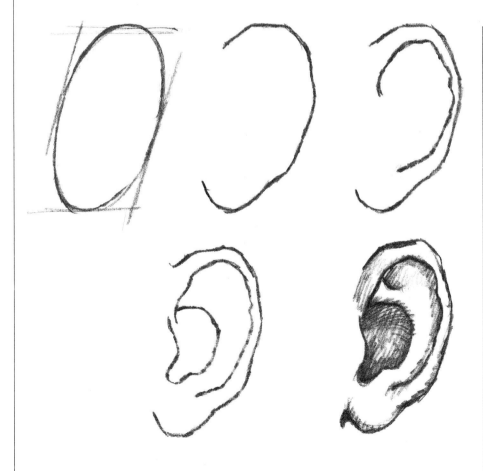

Common Errors: Drawing Ears

Carelessly drawn. The ear is often overlooked too long in the process of drawing the head, and hurriedly stuck on in a rush at the end. Take your time and give ears the attention they deserve, checking the alignment with the eyebrow line and base of nose line.

Not placed in proper perspective on the head. Careful observation will ensure you're getting it right.

Placed too high or too low. This problem exists particularly when we are drawing children; the placement of the ear greatly affects how old the child appears, especially in the front view. If you are having difficulty getting the child the right age, check ear placement. When in doubt, line up the top of the ear with the eyebrow line. This alignment is not so easy to see as the child seldom sits still enough, but just knowing what to look for helps a lot.

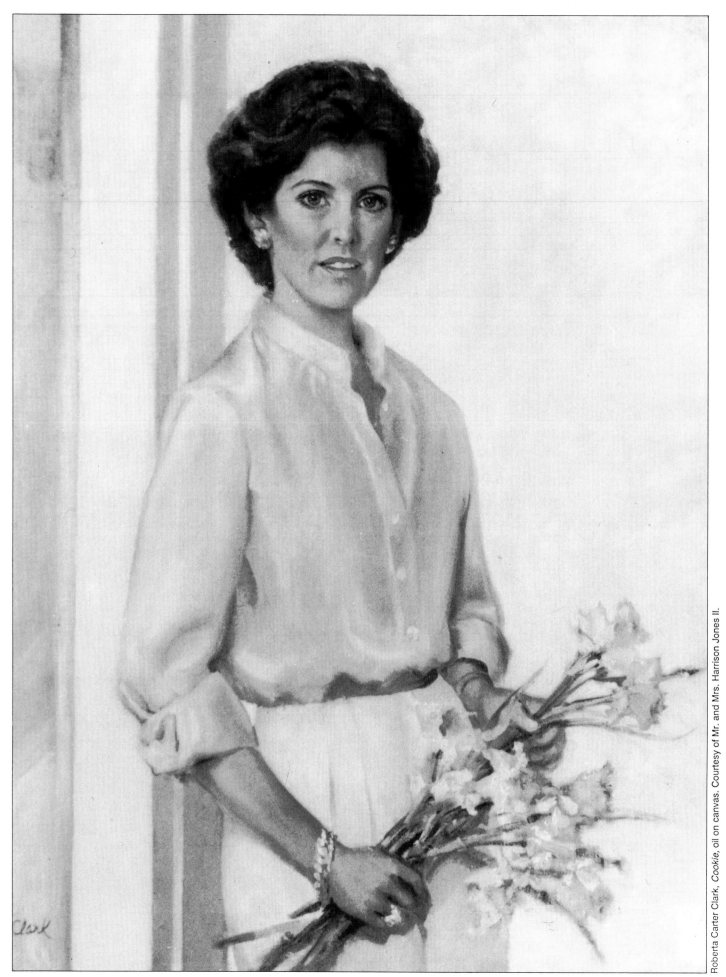

Roberta Carter Clark, *Cookie,* oil on canvas. Courtesy of Mr. and Mrs. Harrison Jones II.

Drawing the Body

When we think of portraits we may automatically think of the head alone, but nearly every portrait you'll ever paint will include more of the subject's body than just the head. There will be the neck, perhaps the shoulders, frequently the torso, arms, and hands, and occasionally the legs and feet as well.

The material in this chapter will help you understand the construction of the parts of the body, how these parts interrelate, and how their construction determines natural movement. To get to know the way the body moves, it's helpful, and even fun, to draw from a jointed wooden mannequin. The adult-proportioned mannequin can be arranged in nearly any pose the human body will assume. These mannequins come in sizes from 1 foot to 26 inches high and stand upright on a wooden base. If you can't find them in your local art store, you can buy them from artist's supply catalogs.

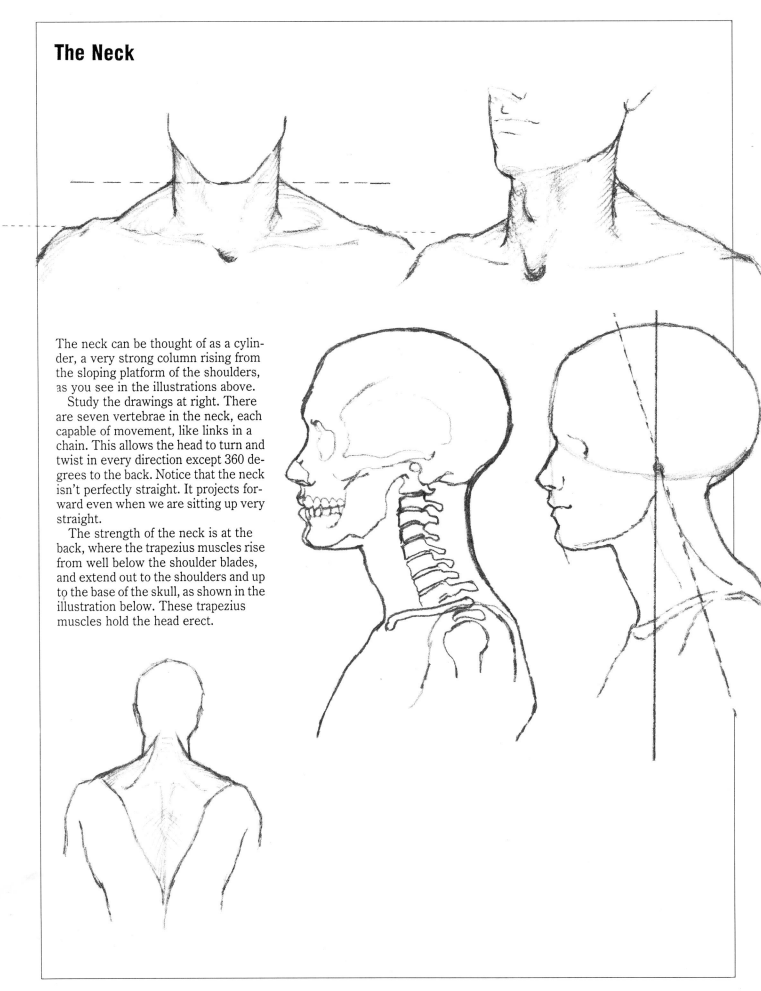

The Neck

The neck can be thought of as a cylinder, a very strong column rising from the sloping platform of the shoulders, as you see in the illustrations above.

Study the drawings at right. There are seven vertebrae in the neck, each capable of movement, like links in a chain. This allows the head to turn and twist in every direction except 360 degrees to the back. Notice that the neck isn't perfectly straight. It projects forward even when we are sitting up very straight.

The strength of the neck is at the back, where the trapezius muscles rise from well below the shoulder blades, and extend out to the shoulders and up to the base of the skull, as shown in the illustration below. These trapezius muscles hold the head erect.

The neck, at the back, begins at a point on a level with the ear opening and the base of the nose. From the front, the visible neck begins at the chin and extends this same distance downward to the collarbone protrusions. Study the drawings at right.

Descending from behind the ears to a pit at the base of the front of the neck are two slender muscles called "bonnet strings" or sternomastoid muscles. These pull the head forward and back and allow the head to turn from side to side. Between these muscles, at the front, you will see a man's larynx or Adam's apple.

Notice that the neck can be stationary and still allow the head to nod forward and be thrown back, as shown in the drawings below right.

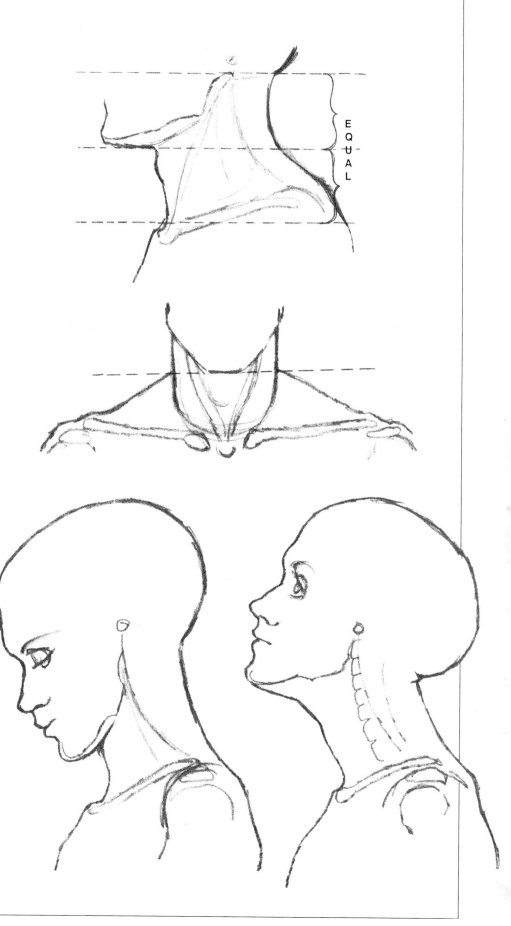

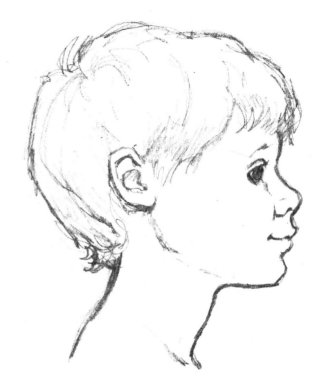

Children's and Youths' Necks

Until a child is three or four months old, the neck is too weak to support the head, which is proportionately very large for the body. The neck in a new-born baby and up to age two is hardly visible as such, but may be indicated by creases in rolls of fatty tissue. As the child grows the neck becomes more perceptible and takes on a rather slender and delicate appearance.

When a boy of sixteen or seventeen becomes active in athletics, the neck thickens. As a portrait painter, you should watch for this, as the heavy, sturdier neck is a good way to indicate a young man growing out of boyhood. All professional athletes show great strength in the neck.

Michelangelo gave all his people sturdy necks, both men and women. There is something heroic about a very strong neck in a painted image.

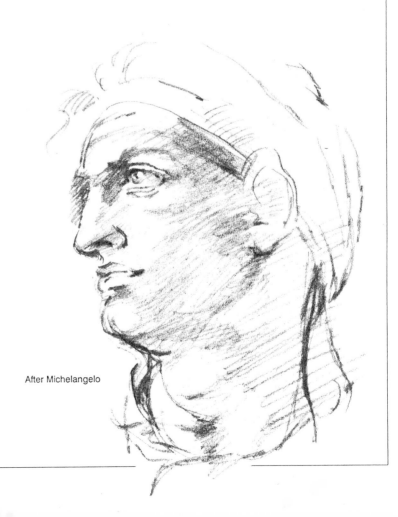

After Michelangelo

Women's Necks

In painting women, the neck might be made to appear longer and attractively curved as an indicator of feminine grace and beauty. No woman was ever beautiful with her head slumped forward, scrunched down into her shoulders. Every beauty holds her head high, with neck extended and erect.

Many portrait painters have stressed the beauty of the "swanlike" neck and the way the head is balanced on it to convey an impression of elegance in their subjects.

Common Errors: Portraying the Neck

The neck too long or too short. Poorly observed. Try to relate the neck to the chin, the collar.

Too thick or too thin. If the neck is too heavy, the figure may look stodgy. If the neck is drawn too thin, the figure may appear weak.

Drawn as a tube with a ball on top of it. The neck looks stiff and unnatural.

No involvement between the neck and the shoulders. Without the smooth flow from the neck to the torso the body lacks grace and movement.

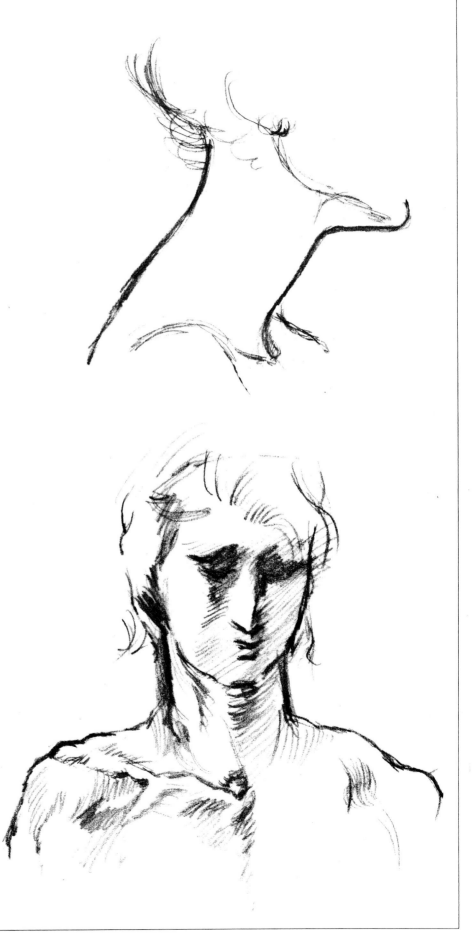

After Michelangelo

41

Shoulders and Torso

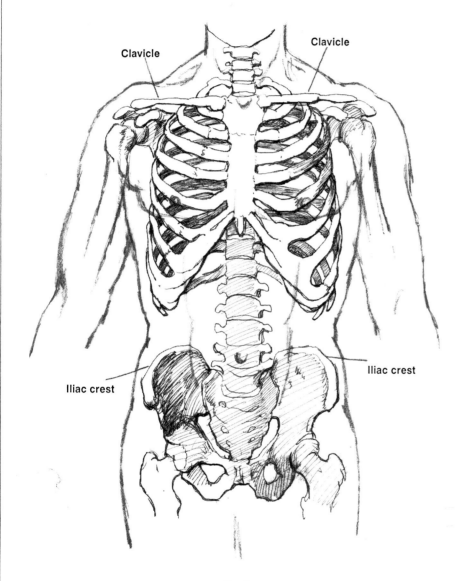

Clavicle

Clavicle

Iliac crest

Iliac crest

Front

The pit at the front base of the neck has two small bony protuberances rising on either side. These are the inner ends of the collarbones, the clavicles, which attach at this central point to the breastbone, or sternum. The opposite ends of these collarbones extend outward to the shoulders.

The shoulders appear as round and full forms. One shoulder can be raised independently of the other, but in most portraits the shoulders are at the same height or very near it, unless one elbow is leaning on the arm of a chair or something similar. As the elbow is higher, so is the shoulder.

The upper half of the torso is the cone-shaped rib cage called the thorax. This "cage" is constructed of the twelve curved ribs on either side which connect to the sternum in the front and the spine in the back.

The upper back of the torso is relatively flat, for there is a flat shoulder blade, or scapula, on either side of the spine partially covering the rib cage. The top edge of this scapula parallels the slope of the shoulder and is thicker at the outer corner where it forms the shoulder joint as a socket for the bone of the upper arm. As a person ages, the upper back becomes more rounded and less flat.

The torso is capable of twisting, bending from side to side, and bending forward and backward, but all this movement occurs only at the waist. The chest and the hips are relatively stationary.

The lower part of the torso is the pelvis, which is made up of the flat sacrum at the base of the spine and a hip bone on either side. The pelvis functions as one stationary unit and no part is capable of movement independently of the other two parts. The hip bones flare out at right angles to each other; each has a ridge at the top called the iliac crest which travels from the back to the front of the body. The lower front corners of these bones meet at center front and form the pubis, the lowest point at the front of the torso. At the outer edge of each hip bone is a socket fitted with the ball end of the femur, a neck-like extension of the thigh bone.

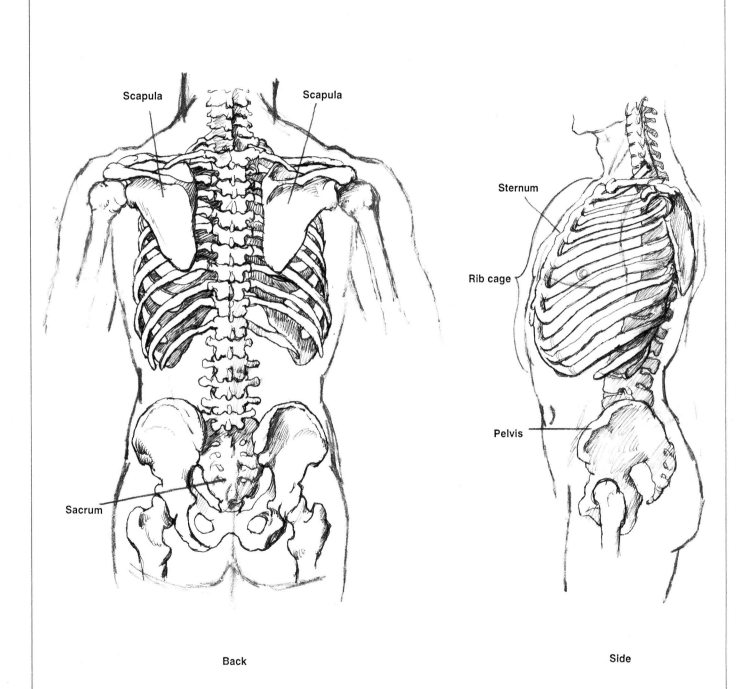

Scapula

Scapula

Sternum

Rib cage

Sacrum

Pelvis

Back

Side

Common Errors: Drawing the Shoulders and Torso

Body bending in all the wrong places. The torso is not really a flexible sausage. There can only be movement front to back, side to side, and twisting movement *at the waist,* the area between the rib cage and the pelvis.

Drawing or painting the figure's clothing awry. The center front of the clothing *must* fall on the center front of the torso, the median line. This includes the vee of an open shirt; where collars button and men's ties knot; or where buttons go down the front of a garment. It's particularly easy to get things out of alignment on a small child's portrait, for children never do give you enough posing time.

Failing to account for uneven weight distribution. Remember, when the figure is standing with the weight on one foot, the shoulder line and the hipline can *never* be parallel, or the figure would fall over. (More on this later in this chapter.)

Getting the proportions wrong. When painting a portrait of a seated figure, it's all too easy to shorten up or visually leave out the part of the torso from the waist to the seat. Carefully measure head-lengths down to the chair seat, then to the knees. Imagine the body in a bathing suit, and block it in as you know, in your mind's eye, it must be. Then put the clothing on.

Front

Drawing the Torso

Stand up and raise your leg to the side, as if you were getting on a bicycle, and feel with your hand where the leg swings out. This spot, the hipline, is critically important to the artist. When drawing the full-length figure, this is where the body divides in half vertically—that is, the distance from the top of the head to the hipline is an equal measure to the distance from the hip-line to the soles of the feet. Also, when the arm is hanging straight down at one's side, this line aligns with the inner wrist. (See the diagram of the man, woman, and children on page 58.)

An artist visualizes this complex machine which is our body in terms of the most simple masses. Thus, blocking in the torso is accomplished quite effectively by drawing the thoracic area as

Back

Side

an egg, the pelvic area as a block, and connecting the two with the flexible spine.

Just as the vertical centerline and the horizontal center, or eyeline, are of critical importance when blocking in the head, so the centerline of the torso, both front and back, is extremely important in drawing your figure correctly. In anatomy, this is known as the *median line.* It's a good idea to use this line as a checkpoint if your figure drawing seems to be incorrect, particularly in the three-quarter view when your figure is in perspective.

And when you are painting portraits, the buttons of the shirt, jacket, or blouse must fall on this centerline, not on the edge of the garment.

The Arms

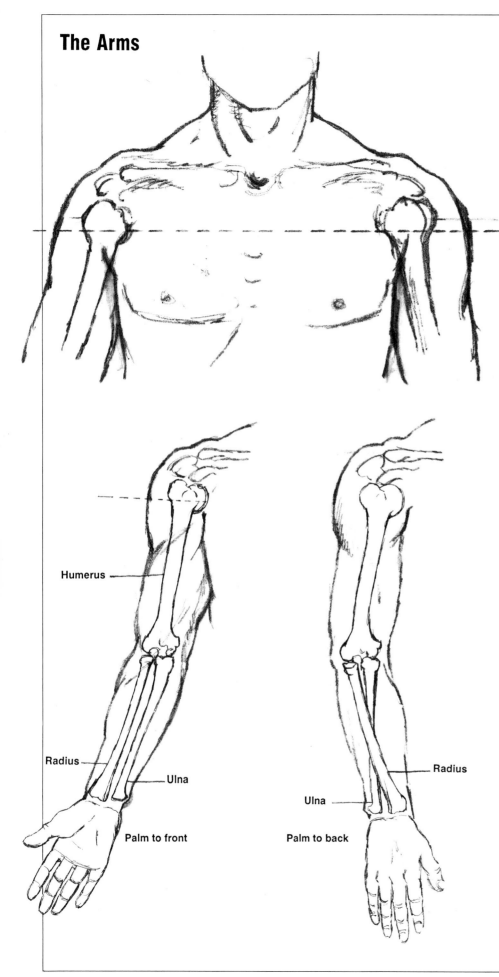

Humerus

Radius

Ulna

Palm to front

Radius

Ulna

Palm to back

By drawing a line across the upper chest through the mass of the deltoid muscles, at the heads of the humerus bones and slightly above the armpits, you'll discover the broadest part of the entire body. The shoulders are *not* broadest at their upper corners! Study the arm carefully; from this point of greatest thickness near the shoulders, the arm begins to taper until it becomes smallest at the wrist.

The arms are capable of radial movement in any direction at the shoulder joint. At the elbow, only side-to-side and forward movement is possible. The upper arm is round and is made up of only one bone, the humerus. Deltoid, biceps, and triceps muscles are prominent in the male. These muscles are less pronounced in the female.

The forearm is made up of two long bones, the radius and the ulna. It is heaviest near the elbow, where it is round. Two-thirds of the way down it tapers to a flat mass at the wrist.

Holding your hand flat, palm up, the ulna is on the little finger side. This bone is larger at the elbow and smaller at the wrist. The radius is the bone on the thumb side, and is larger on the wrist end, smaller at the elbow end. When you turn your hand over, palm down, the position of the radius and the ulna don't change at the elbow end, but midway down the forearm the radius twists over the ulna, allowing the hand to lie flat in this position as well. Try this; with your hand, you can easily feel the interaction of these two bones.

There is a sharper angle at the outside of the elbow joint, a rounder curve inside. When the arm is bent (hands resting in lap or elbow leaning on arm of chair), the point of the elbow is found under the *center* of the upper arm, not in a line with the back of the upper arm as shown in line *A* to *A* in the sketch at far right.

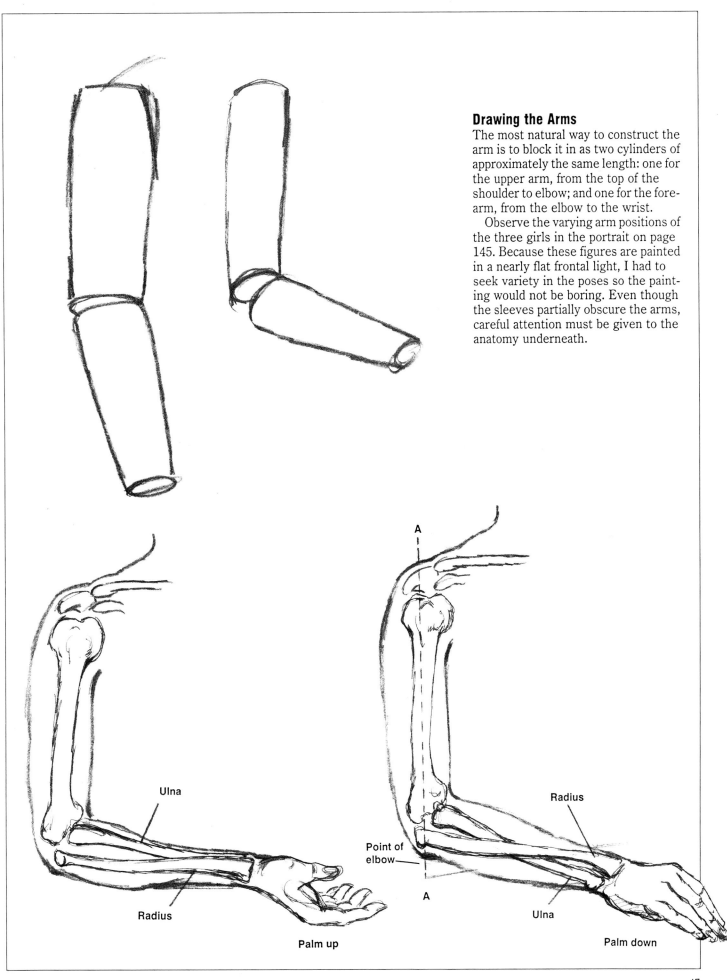

Drawing the Arms

The most natural way to construct the arm is to block it in as two cylinders of approximately the same length: one for the upper arm, from the top of the shoulder to elbow; and one for the fore-arm, from the elbow to the wrist.

Observe the varying arm positions of the three girls in the portrait on page 145. Because these figures are painted in a nearly flat frontal light, I had to seek variety in the poses so the painting would not be boring. Even though the sleeves partially obscure the arms, careful attention must be given to the anatomy underneath.

Ulna

Radius

Palm up

A

Radius

Point of
elbow

A

Ulna

Palm down

The Hands and Wrists

Common Errors: Drawing the Arm

Making the arm too stringy and without form. This is really the only major fault in drawing the arm. The bare arms on a muscular man are easy to draw, but how many portraits of athletes will come under your brush in your lifetime? (Unless you specialize in circus people, dancers, or sports figures—wouldn't that be great luck?) Try to paint the bare arms of an eight-year-old boy. Now there's a task to test your mettle! And slender young women, too—not so easy. For one thing, the arms *do* look stringy, but you as an artist must add form and solidity.

Note: As you study that thin little arm, you really need something to go *across* the form. This is where your artistry comes in. Put the paint on across the form, the charcoal strokes as lines across the form, to indicate its roundness. This truly is the answer. *Never* paint an arm with up-and-down longitudinal strokes. Of course, the curve of a sleeve helps immeasurably, as does a watch or a bracelet, to make the arm appear round, so take advantage of them when you can.

Drawing hands takes a tremendous amount of practice. After all, if you're going to include hands in your portraits, you want them to be as well thought out as the head. Your sitter's hands express another facet of his or her personality. They add character to a man's portrait, grace and poise to a woman's portrait, and charm to a child's portrait. And if you can't put in the hands, you're forever limited to just head and shoulder portraits—not much fun!

Here are some facts about the hand and wrist: The wrist is a form similar to a flat block, approximately twice as wide as it is thick. The wrist rotates with the hand on the forearm, as discussed on the previous page.

When the hand is at rest, palm up or palm down, in one's lap or on a table, the front of the wrist, on the thumb side, is higher than the little-finger side. Prove this to yourself by studying your own wrist and hand.

When the arm lies flat, palm down, on a flat surface, there is always a hollow under the wrist. The arm and hand *never* rest on the wrist, but on the heel of the hand and the fleshy part of the forearm near the elbow.

The hand is made up of two masses: the hand itself and the thumb. There are four bones in the hand mass, twelve in the fingers, and three in the thumb.

Blocking in the Hand

The hand is so complex a structure and capable of so many movements that most students are apprehensive about drawing or painting it. However, to the portrait painter, the hand is second in importance only to the head, adding so much to the character of the work that we absolutely must give it our best effort.

Let's set aside our fears and attempt to see the hand as a geometric form. If we look at it as a mitten with thickness, we can master it. This is a valid way to block in the hand in any medium—charcoal, oils, watercolor—and can be relied on to get you started on the hands in all the portraits you do for the rest of your life.

This first form below is a good beginning, but you'll never see a hand in this position—out flat—on real people, so we must explore further.

Palm up

Palm down

The knuckles (on the back of the hand) are halfway between the wrist and the end of the first finger, the index finger. Check this on your own hand. Let your blocked-in mitten bend at this point so that the "hand" appears more natural, slightly cupped. The middle finger is the longest and it determines the length of the hand.

Equal distance

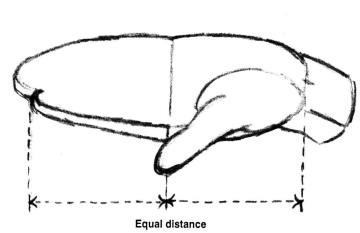

Equal distance

The finger section *A-B* is jointed twice more and can bend forward at these joints all the way to a tight fold, a clenched fist.

The hand section *B-C* is capable of movement at the wrist forward and backward and side to side.

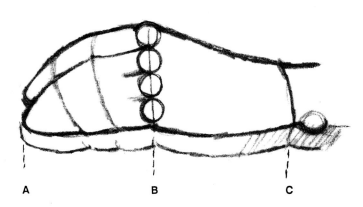

A B C

Construction of the Hand

The first section of the finger, starting at the knuckle, is the longest of the three finger parts. The second section, in the middle, is shorter than this, but longer than the third section, the fingertip.

As none of the fingers are of equal length, none of these divisions line up across the finger mass. However, these segments—the longer section from the knuckle to the next longest to the shortest—are still the structure of every finger.

Each section of each finger is always *straight, never* curved. Even when you see the most graceful willowy hand movements, the fingers may curve, but each segment (called a phalange) is straight. Draw these finger sections with straight lines on the top side, and with rounded fatty pads on the lower, the palm side. Think of each segment as a cylinder and you will get the perspective right.

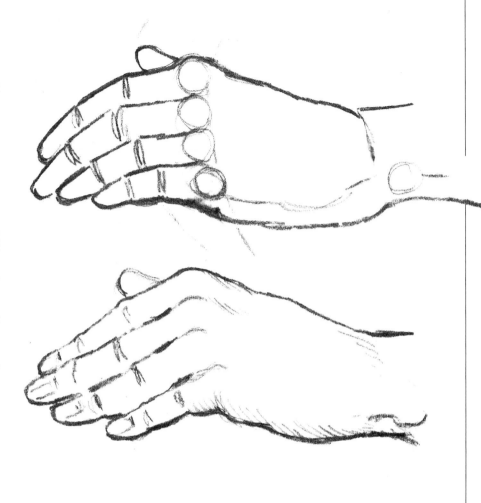

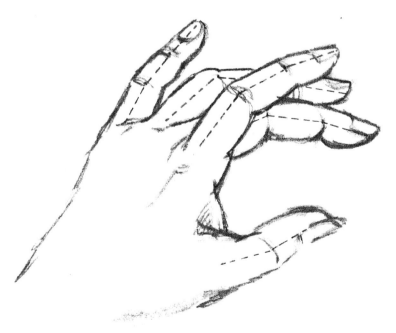

We have been studying the back of the hand. Now turn the hand over, palm up as in the illustrations at right. Looking at the fingers, you can see there are three parts to each finger — three fleshy pads, all quite *equal* on any one finger. Of course, since the fingers are not all the same length, the pads and the folds between them do not line up with each other across the hand.

You'd think the folds on each finger would match the joint divisions on the back of the finger, wouldn't you? Study your own hand carefully.

There is the fold at the third joint, the fingertip joint. Then the second section and the second joint. Then the third section and the first joint. On the palm side, this is where the fingers end and the palm begins. Now fold your hand at the knuckles — you are in for a surprise — the fingers do *not* fold at this third joint where they join the hand; the knuckle joint on the back corresponds with a *fourth* fold across the palm of the hand! *This* is where the finger action starts!

Look at your hand from the side to prove that the third fold on the inside is only halfway between the second joint and the knuckle joint on the back. Curl your fingers halfway closed and see this amazing fact for yourself, first from the thumb side, then from the little finger side. There is no movement where the fingers *appear* to attach to the hand, but at the knuckles further down in the hand mass. Knowing this will help you to draw hands in natural positions.

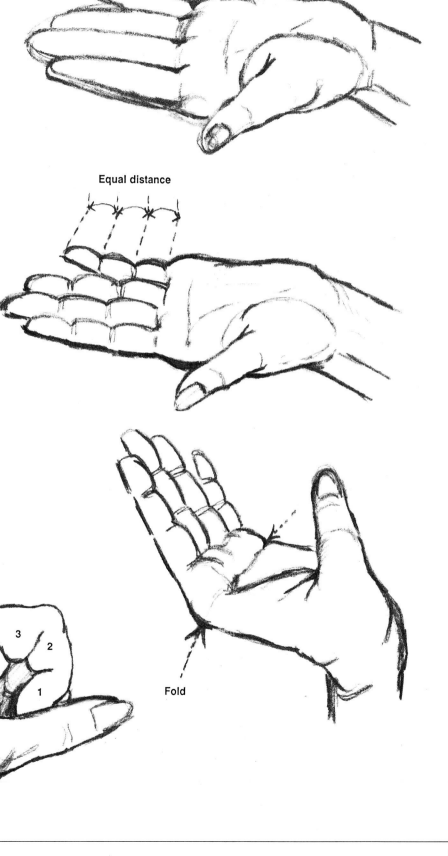

Equal distance

Fold

4 3 2

1

Fold

The Cupped Hand

The hand is naturally cupped when in repose. We really have to *push* to flatten our hands on a flat surface. Cupped from fingertips to heel, the hand is also cupped from side to side. Knowing this will help remind you to *round* the form *across* the knuckles in any view.

The only time the hand is flat is when a conscious effort is made to extend the fingers.

The Thumb

The thumb may be considered a long form with squared sides. It has three joints; the base joint is out of sight in the hand and connected to the wrist.

The fingers and the thumb fan out from the wrist. However, the visible joint where the thumb joins the hand is nowhere near the finger joints and is never in a line with them unless the hand is tightly closed, as when making a fist. The thumb dominates the hand, particularly when the hand is holding on to something.

The thumb appears most often at right angles to the fingers. You can check this easily: when you look at your hand palm down and see the fingernails in full view, you see the thumbnail in profile. Conversely, when looking at the thumbnail full view, you'll see that the fingernails are in profile.

The Nails

Adding the fingernails helps considerably in conveying the form and direction of the fingers and hands. The nail starts halfway down the fingertip segment of each finger and the thumb. On a man's hand, keep the nails quite square; on a woman's hand, make them oval and a bit longer. Most portrait painters idealize the hands by making the fingers longer, and the fingernails in a woman's portrait look better if they are colored a soft pink or coral. Adding the highlight on the shine of the nails makes them almost like jewelry on a man or a woman. And on a small child, shiny nails make the tiny hands look very clean.

Drawing and Painting Hands

As for color, the fingertips are always a warmer hue than the rest of the flesh. In fact, *all* the extremities—hands, feet, ears, and nose—are warmer, that is, pinker or rosier.

A child's hands are fatter, rounder, less defined, less "controlled" than an adult's. Although the forms of their fingers appear to be round, you will have greater success if you describe them with straight lines.

If you are right-handed, practice drawing your left hand in various positions: i.e., palm up, palm down, clenched, pointing, holding a letter or a flower. If you are left-handed, draw your right hand. The sketches on the next page will give you some ideas.

In general, it's safe to say you should try to block in *any* form with straight lines. Your work will be stronger and more solid. It's a simple matter to round off any area in the finishing—the *start* is what counts!

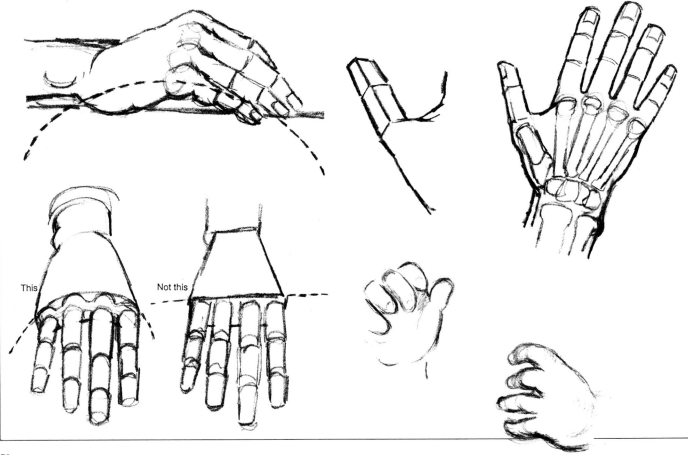

Common Errors: Drawing Hands

Hands too large or too small; out of proportion. The length of the hand from its heel to the tip of the longest finger is considered to be the length of the face, from chin to hairline.

The "bunch of bananas" syndrome. Fingers appear to be hanging off a block-like form (which is the hand) rather than growing out from the knuckles.

Too much definition. Draw the separate cylinders of the fingers, but when finishing, eliminate many of these lines and treat the fingers as masses with less articulation.

Out of perspective. Be conscious of your viewing position, and try to draw the finger cylinders in proper perspective.

Awkwardly drawn wrist. You can learn to draw every part of the human body in any position from memory—*except* the wrist. Keep it as a flat block and it will give you less trouble.

Summing Up

By now you're probably thinking, "How am I going to remember all that?" No one expects you to remember it! I only hope one day when you're in the middle of a portrait and having trouble with the hands (all of us do, you know), you'll look back at this chapter and find the answer to the problem that's plaguing you. Most often the problem is in the basic construction and not the details. I can't stress this too strongly. I could give you the clearest, sharpest photograph of hands in the world, and you could spend days and weeks painting from it, but without real knowledge of how the hand is constructed and how it works, your painting will be lifeless and without substance. Remember, artists don't paint only what they see; they paint what they *know!*

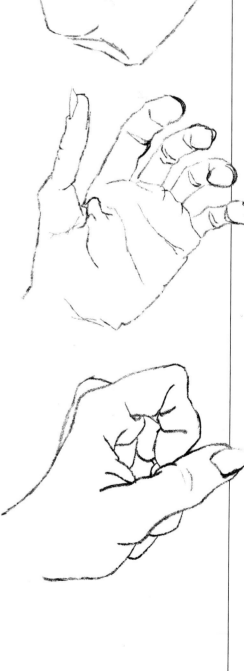

The Legs

You won't often be asked to include legs and feet in a portrait of an adult, but if you decide to make portrait painting a career, one day you will most certainly be commissioned to paint a full-length portrait of your client. Even if the man's legs are covered by trousers and the woman's by a lovely gown, you still need to know what the body is doing underneath all that fabric. Also, to paint the standing figure you have to know how the weight of the body is supported.

The thigh—the form from hip to knee—is all one bone, the femur. The femur is the longest and strongest bone in the body. The femur is attached by a necklike form to the pelvis in a ball and socket formation. This allows the leg to move freely forward, backward, sideways, up and down.

As the thigh descends to the knee, it centers itself under the central weight of the torso. The knee is in a direct line with the hip joint.

The leg from knee to ankle, like the forearm from elbow to wrist, is made up of two bones side by side. The heavier bone is the tibia, and the narrower bone is the fibula. The narrow second bone, the fibula, allows the ankle to rotate, although we cannot flop our foot over 180 degrees as we can our hand.

Seen from the front, the inner ankle bone is obviously higher than the outer protuberance.

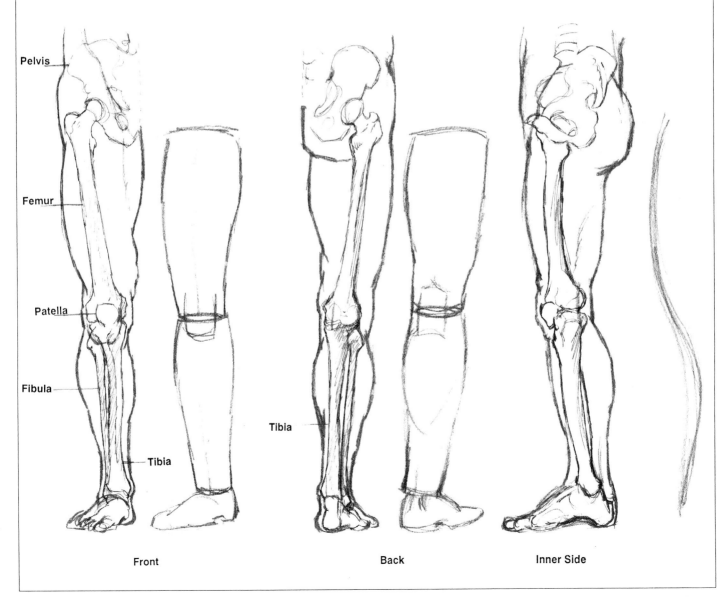

Pelvis

Femur

Patella

Fibula

Tibia

Tibia

Front Back Inner Side

Drawing the Leg

The leg in profile presents an elongated "S" curve. The kneecap (the patella) is held in place by extremely strong ligaments attached to the fibula below the shinbone. The leg resembles two cylinders of equal length, one from the upper thigh to the kneecap, and one from the kneecap to the inner ankle bone.

When a figure is seated with the legs bent at hip and knee, drawing the thighs is much easier by seeing them as cylinders in perspective and proceeding as suggested in these drawings.

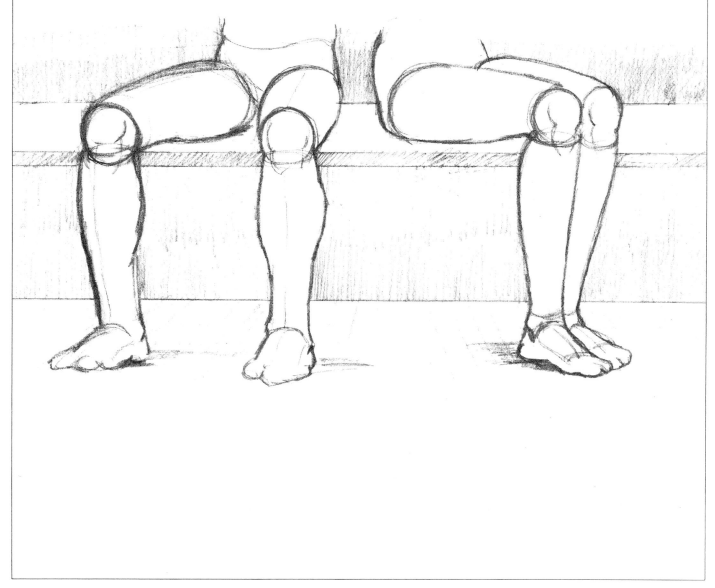

The Feet

The foot is a wedge shape that flattens out at the toes. When a subject is standing, the outside of the foot, from the little toe to the heel, is usually flat on the ground. The main arch of the foot is on the inside, normally raised from the ground. This gives spring to the foot as it steps.

Notice that the big toe is often separated from the other four toes, rather like the thumb is separated from the other fingers.

When drawing the foot, try blocking it in with straight lines for strength and support. And block in the toes as small cylindrical forms. Learning to draw the toenails properly will help put the foot in perspective. This is important since all views from the front present the foot in perspective.

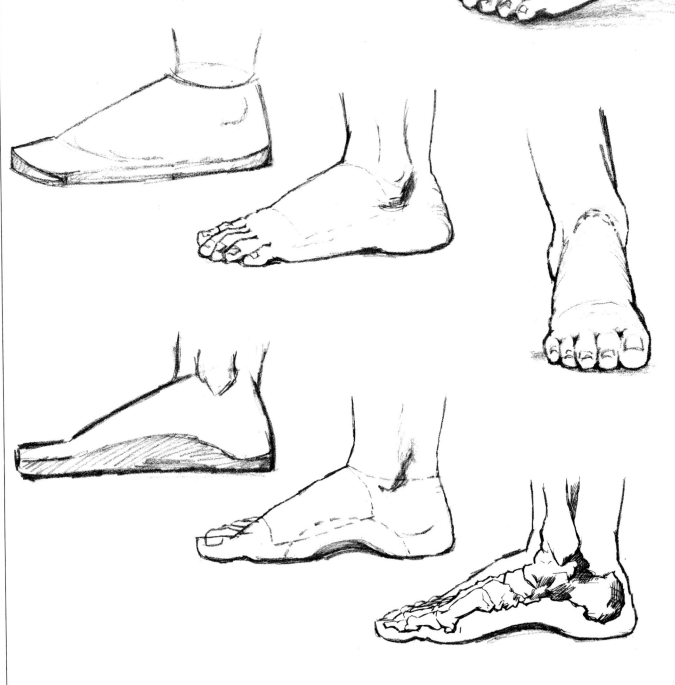

Common Errors:
Drawing Legs and Feet

Foot not strong enough or large enough to support the body.

Proportions of the foot are off. Feet with toes can look like paws if you're not careful!

Not rounded, lacking form. If you're having trouble with the bare feet in a portrait, paint sandals on them—the sandals will help describe the foot.

Poorly placed in relation to the rest of the body. Sometimes you'll see a portrait of a woman in a long dress that looks as if the painter just stuck the feet on anywhere at the edge of the dress, with no thought of any follow-through from the hip to thigh, to knee, to ankle, to foot. Don't let this happen to you. Try to draw the limbs beneath the clothing so the feet will come from the legs! Of course, it would be ideal if you could draw your client in a bathing suit first and then paint the gown on the figure, but you're not likely to have this opportunity. You just have to use your knowledge and your imagination and search for key points—especially the knees—beneath the fabric. Make it a rule for yourself: *Always* construct the body inside the clothing first.

Children's Legs and Feet

Though you may seldom be called upon to include legs in an adult's portrait, if you paint children you will have many opportunities to depict their little legs. The construction of a child's leg and foot is the same as the adult's, but there is less definition of muscle and the forms are more rounded.

An infant's foot is round, not flat, on the sole, as he has not worn shoes or walked enough to flatten the soles. The feet are fatter than those of an adult and the toes can be very tiny. Again, the small toenails help to establish the angle of the foot.

Many times you will prefer to paint a small child barefoot, even in fairly dressy clothing. The bare feet take away the over-formal look and remind us that the child is more free and natural than adults.

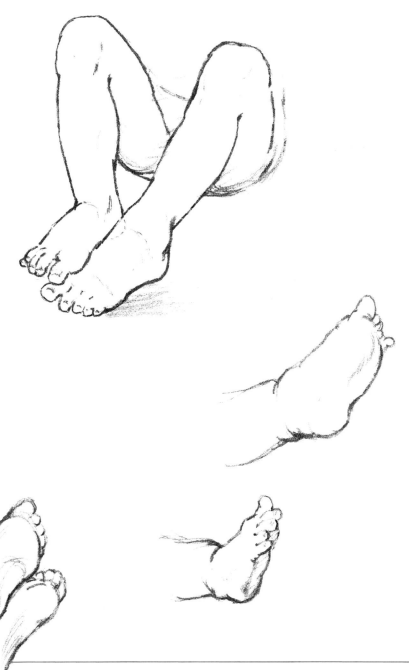

After Mary Cassatt

Proportions of the Body

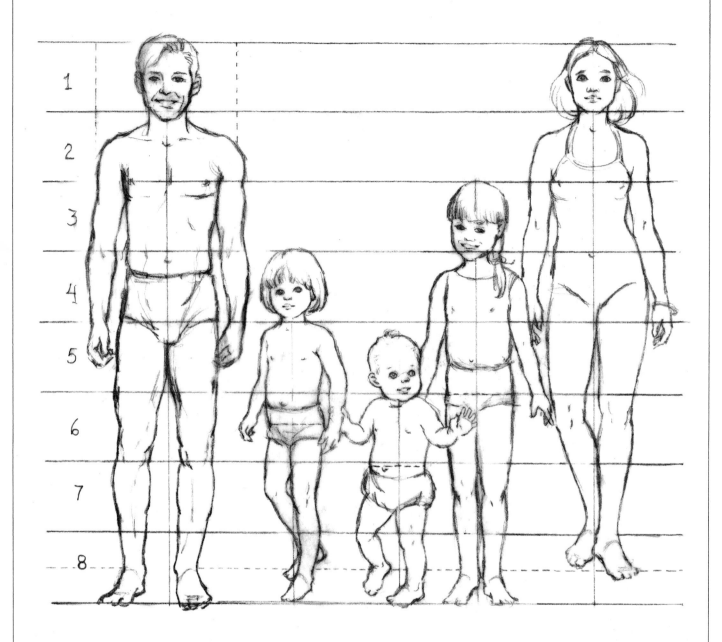

To get the proportions right, it makes sense to draw the large forms first, and then begin constructing the masses by means of light and shade and defining the larger planes. As you continue to work, the portrait will gradually get more and more refined, until eventually you arrive at the likeness and individuality of your sitter. I know an experienced portrait painter who can begin with one eye and build the whole head and body around it, but don't make it this difficult for yourself yet. As a student, *always* draw the figure as a whole before you put in the details of the head, hand, foot, or face.

Adults Using the head length as a unit of measurement, the adult human figure is 7 to 8 heads high. The idealized figure is 8 heads high, lending a feeling of dignity and elegance. (*Never* make the head larger than it appears; this makes the figure look clumsy.) A good size for the average figure is 7½ heads.

In this illustration, the male and female figures are 7½ to 8 heads high. From the top of the head to the hipline measures 4 heads, and from this line to the heel measures 3½ heads. Study the diagram to see which parts of the figure can definitely be located by the head unit of measurement. Of course, the first head-length is the head; the second is the distance from the chin to the nipples; the third to just above the navel but below the waist; the fourth head-length takes us to the hipline. From this line it is 1½ heads to the knees. The center of the figure is about at the fourth head line, or just above that line.

In the male adult, the shoulders are approximately 2 head-lengths wide; this is the widest part of the male body. In the female body, the hips are often as wide as the shoulders.

When the arm hangs at the side, the elbow touches the rim of the hip bone, the iliac crest, and the inside of the wrist is on a level with the halfway point of the figure. The fingers reach a little below the center of the thigh.

Children In children the head is larger in proportion to the body. The central figure in the diagram at left, the one-year-old, has a head one-quarter the length of its body. The central point, indicated by the dotted line, is at the waist; above the navel may be easier to determine, as an infant this age normally has no waist.

The four-year-old (second from left) has a head-length approximately 20 percent of the body length, which, therefore, is 5 heads high. The central point is 2½ head lengths from the top of the head.

The eight-year-old child (fourth figure from the left) is about 6 heads high, and the halfway point is moving down nearly to the adult halfway point, the hipline. (The three children are in proportion to each other but not to the adult figures in the drawing. In actuality, their heads are smaller than adult heads, but drawing them in these sizes makes the proportions easier to see and to remember.)

Drawing from Life You can look at these diagrams and study your own body, but there's no substitute for drawing from the live model. If you can't find a life drawing class in your area, start one. Perhaps you can get members of your family or a classmate or friend to pose resting, reading, or even watching television! Portrait painting is really only an offshoot of life drawing—a sort of life drawing with personality superimposed.

Some students are interested in anatomy, the study of the skeleton and the muscles. Others don't have the slightest desire to know what goes on under the skin. But as a portrait artist, you need to know something about anatomy. If you want to study it in more detail, some excellent texts on anatomy for artists are listed in the Bibliography. Anatomy for medical students is a much more definitive study, but you don't have to master it in this great a depth. Even if you keep just this book near you while you are observing and drawing the live figure, you will see real progress in only ten drawing sessions.

Practice drawing people of both sexes, all ages, seated, standing, in a variety of positions. Most artists continue to draw from the figure throughout their lifetimes. To draw the figure well—to re-create its mass and its movement—is a highly desirable skill. And there isn't an artist alive who ever feels he draws the figure as well as he should.

Hint: After deciding on a pose for your subject, get into the habit of measuring one head-length. Extend your arm, hold your brush vertically, and measure along the handle of the brush. Then measure the second, third, and fourth head-lengths to get a rough idea of just how much of the figure can be included on your canvas or paper.

Weight Distribution

We have learned to block in the figure with jointed cylinders for arms and legs, a thoracic egg and a pelvic block for the torso, a mitten for the hand, and a wedge for the foot. However, there's more to it than that. We must also consider shoulder and hip construction lines from the very beginning of our sketch, for these lines tell us instantly how the figure is standing and how the body's weight is distributed.

Using Construction Lines

The following construction lines are particularly helpful: the shoulder line passes from one shoulder to the other through the neck and is paired with a second line under the rib cage which *always* parallels it. The line at the hip is paired with a second line through the tops of the iliac crests of the pelvis; these two also *always* parallel each other. (See lines *A* and *AA*, *B* and *BB*).

Only when the body is seen standing perfectly erect with the weight distributed equally on both feet, are all the shoulder and hip construction lines parallel to each other.

When the weight is shifted to one foot, say the left, as shown in this female figure, both the shoulder line and the hipline bend toward each other. The right nonbearing leg appears to be longer than the left supporting leg. The nonbearing leg can be bent, or extended to front, back, or side—it doesn't matter, for it isn't being used to hold the body upright, but just to balance its weight. Just watching for this shoulder-hip relationship will help your figure drawing look more natural.

Looking in a mirror, try it yourself. Stand with your weight on your right leg and raise your right shoulder. Uncomfortable! As you lower your right shoulder and raise the left, your body stands relaxed.

The Plumb Line

When a subject stands with the weight on one foot, the inside of the ankle supporting the weight is in a direct line straight down from the pit of the neck. This holds true whether the body is viewed from the front, back, or side. This very important line is called the *plumb line*.

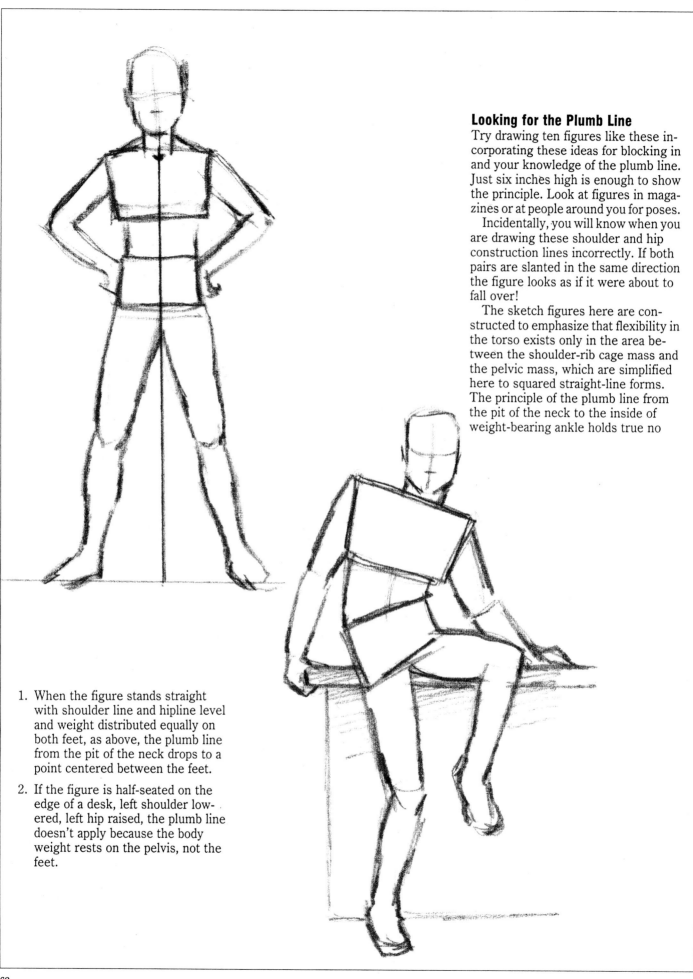

Looking for the Plumb Line

Try drawing ten figures like these incorporating these ideas for blocking in and your knowledge of the plumb line. Just six inches high is enough to show the principle. Look at figures in magazines or at people around you for poses.

Incidentally, you will know when you are drawing these shoulder and hip construction lines incorrectly. If both pairs are slanted in the same direction the figure looks as if it were about to fall over!

The sketch figures here are constructed to emphasize that flexibility in the torso exists only in the area between the shoulder-rib cage mass and the pelvic mass, which are simplified here to squared straight-line forms. The principle of the plumb line from the pit of the neck to the inside of weight-bearing ankle holds true no

1. When the figure stands straight with shoulder line and hipline level and weight distributed equally on both feet, as above, the plumb line from the pit of the neck drops to a point centered between the feet.

2. If the figure is half-seated on the edge of a desk, left shoulder lowered, left hip raised, the plumb line doesn't apply because the body weight rests on the pelvis, not the feet.

matter which view of the figure is portrayed: back, front, or side. The center back and center front lines are lightly indicated on the figures on this page to show that they are independent of the plumb line.

If you practice sketching small figures like these for fifteen minutes three times a week, soon you'll be able to sketch people anywhere—in a bus station, at a party, at the beach—wherever people are standing about, waiting, or conversing. You will be able to sketch convincing figures from your imagination as well. Then when you have a new portrait client, you can do several quick sketches suggesting possible poses as a logical first step in the development of the portrait. Remember, you gain confidence as you gain facility.

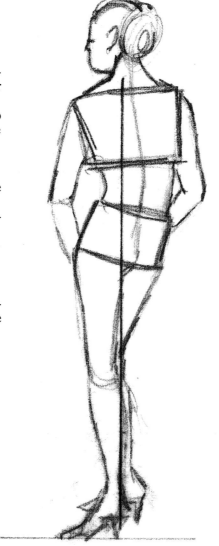

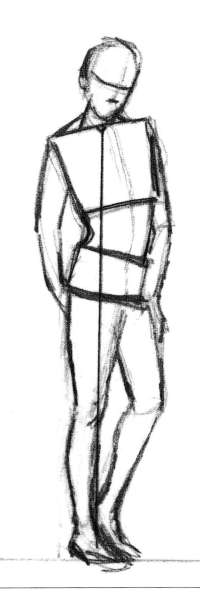

3. When the figure is standing (seen from the back, above) with weight on the left leg and foot, the plumb line runs from the pit of the neck in front to inside the left ankle. The left shoulder is dropped and left hip raised.

4. When the standing figure is slightly turned, with weight on the right leg and foot, the plumb line falls from the pit of the neck to inside the right ankle. The right shoulder is dropped, the right hip raised.

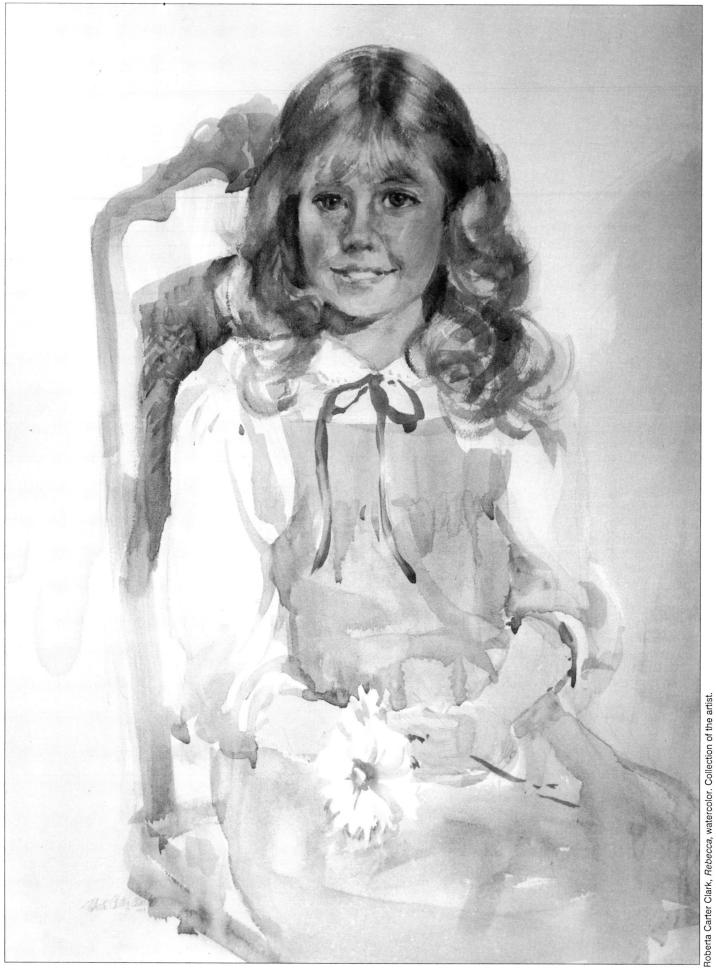

Roberta Carter Clark, *Rebecca*, watercolor. Collection of the artist.

DRAPERY: CLOTHING THE FIGURE

Your rendition of clothing is a powerful tool for designing a portrait beautifully. It can add a great deal to the feeling of reality you wish to achieve.

Clothing is just fabric lying flat until someone puts it on the body. For all of us, our clothing means excess fabric, enough so we can move—bend, sit, crouch, walk. Since you will be painting many types of fabric, it's important to understand the individual characteristics of each one.

There are thin, fine, clinging fabrics like chiffon, which is sheer enough to reveal the forms within; silk; and satin, which is also shiny. There are medium-weight fabrics like cotton (crisp or soft); taffeta (crisp and angular); knits (used for T-shirts and sweaters); and woolens for men's and women's suits. There are heavy woolens for coats (soft but bulky); velvets (pile fabrics that absorb light to the extent they show no highlight but rather a rim light on the edges of the forms). There is fur (another pile material that can be flat and glossy like broadtail or longhaired like lynx). The list goes on and on.

Observing Folds in Fabric

It's important to really notice the fabric in the clothing of people you see around you and study the differences. Mannequins in store windows and photographs in fashion and sports magazines are also good sources for study.

The weight and texture of the fabric controls the manner in which it drapes, wrinkles, or folds. The condition of the fabric—whether it is wet or dry, old or new, rumpled or pressed—also affects its appearance. Even though each fabric performs differently, we'll develop a method so that you can begin to understand what's occurring when you see a sleeve on the arm you are painting, or a scarf around that neck, for all fabrics make the same kinds of folds.

Fabric Lying on a Form Lying-on folds are just that—the fabric follows the form it's lying on. Spread out on a table, fabric looks flat. On a cylinder, or an arm or a leg, it hangs, but not quite straight down because it follows the form a bit before falling. Always look first for the areas of fabric that touch the form beneath.

Fabric Going Around a Form Look for instances where fabric appears to go behind a form and come out on the other side, such as a collar does around a neck. As we know from our anatomy work, the back of the neck is flatter and higher than the front of the neck, which is rounder and lower. This makes the front of a garment appear to dip down at the neckline in a round manner while the back of the collar or neckline lies higher and flatter.

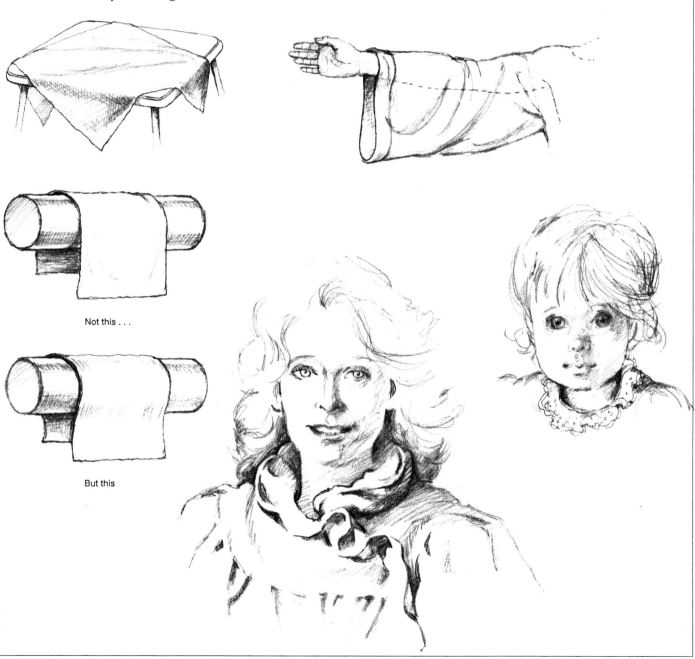

Not this . . .

But this

You could think of the folds on a cylindrical form—such as the arm, leg, or torso—as curtain rod rings around a rod. These folds are drawn mostly with curving lines. Just remember that without the rod, the rings would be lying in a heap, and without the arm the sleeve would be a floppy tube of fabric. Draw the arm first, with its gesture and movement; then lay the folds over the form like curtain rod rings.

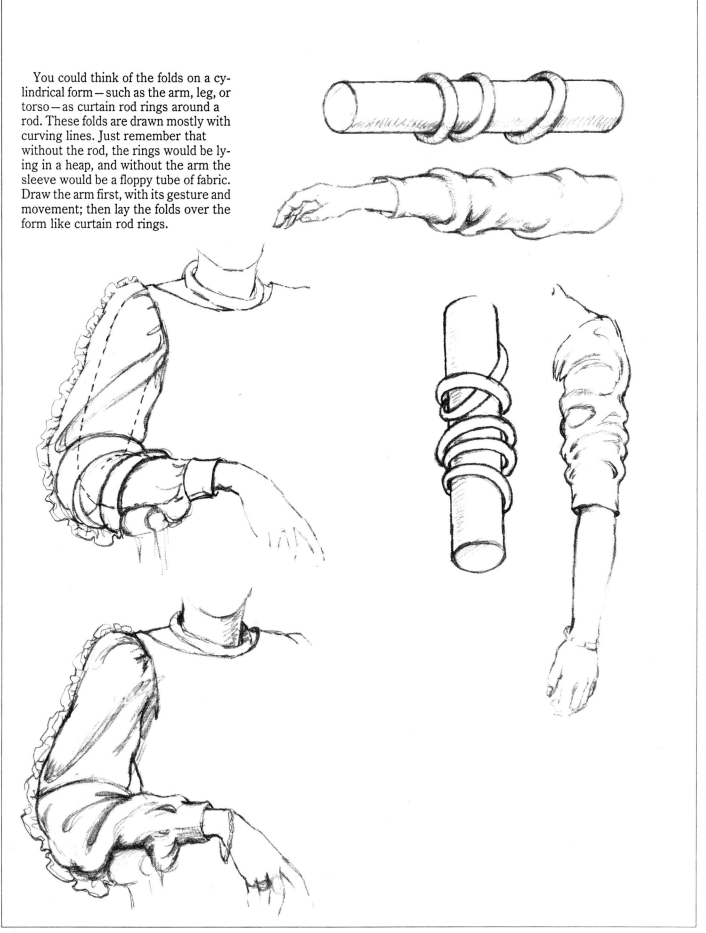

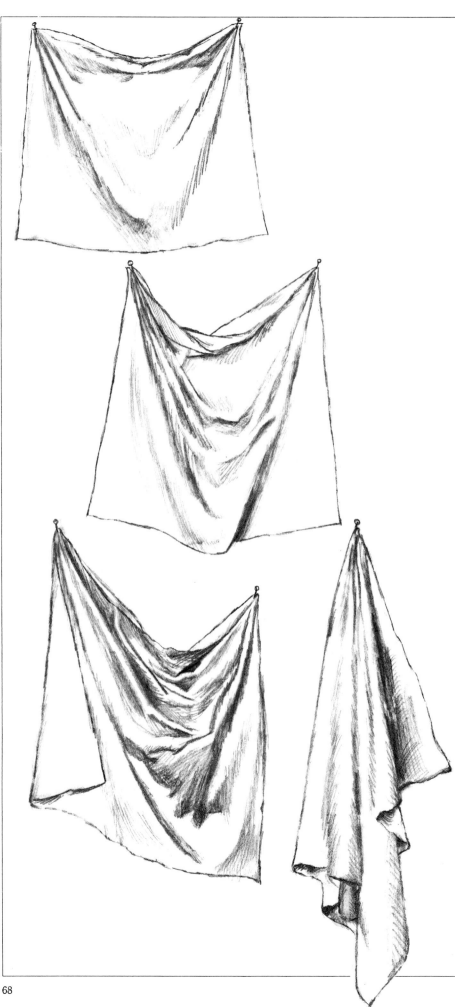

Fabric Hanging Hanging folds are affected by gravity and the weight of the fabric. These folds are drawn mostly with straight lines.

To study the way fabric hangs, get a piece of soft white cotton or cotton-blend fabric the weight of sheeting, about 48-inches square, and some pushpins, tacks, or tape.

Put the pins through the cloth at the two top corners and attach the fabric to the wall surface. As you move each pushpin with the fabric closer together, you'll see the fabric begin to drape a bit.

Leaving the pins at the corners of the fabric, move each top corner about four inches closer to the other, keeping the pins at the same height. You'll see the fabric now drapes into swag folds because the weight of the material is being pulled by gravity into triangular forms. Try to see the folds as forms with a halftone side, a light plane which is the top plane, and a shadow side. Use a spotlight if necessary.

Keeping the pushpins at the two top corners of the fabric, move one now to a spot on the wall about eight inches lower than the other. The folds are now off-center, and you are getting swag folds and hanging folds. Notice that the swag fold shadows are composed of broad triangular forms, while the hanging folds are more like "pipes" (organ pipes, that is).

Hang the fabric now using just one pushpin somewhere along the top edge of the fabric, but not at the corner. You will see there are no more swag folds, only pipe folds and excess fabric hanging as a jabot—a cascade of frills down the front of a shirt—might.

Hint: In all of these swag and hanging folds, the lines radiate from a hub, a point of suspension—in this case, the pushpin. Flip one corner of the excess cloth to the front to overlap the rest and observe what happens.

Fabric Pulling Pulling folds are action folds and are usually drawn in curved lines. In these drawings of seated trousers at right you can see the outside fabric stretches taut over the knee. The lines radiate from the smooth ball of the knee. The inside bunches at the front where the stomach meets the upper thigh, and again at the back of the knee. The fabric is stretched smooth over the buttocks. There are hanging folds below the knee where the fabric hangs free, and there's a lying-on fold where the trouser fabric hits the shoe.

In the standing trouser drawing below, you see gathered fabric puckering from the elastic waistband; puckered folds at the crotch; fabric pulled taut over the right knee, and bunched inside the knee bend; hanging folds where the trouser fabric hangs free from the left hip; and lying-on folds where the fabric of the right trouser leg follows the calf of that leg.

Fabric Hanging from the Waist
When drawing a skirt that's either gathered or pleated, the largest folds are at the center of the body; they become smaller toward the sides. The folds are in perspective.

In the drawing of the woman's skirt, the fabric is soft—maybe a silk crepe. The pleats and gathers fall very straight down from the hips and stay close to the body beneath.

In the child's skirt the fabric is more crisp and has more body—perhaps it's a cotton. The gathering of the skirt at the waistband pushes the stiffer fabric out and away from the body. In this drawing you also see one way of handling still another fuller ruffle of fabric. Note the small ruffle trim applied to the skirt as well.

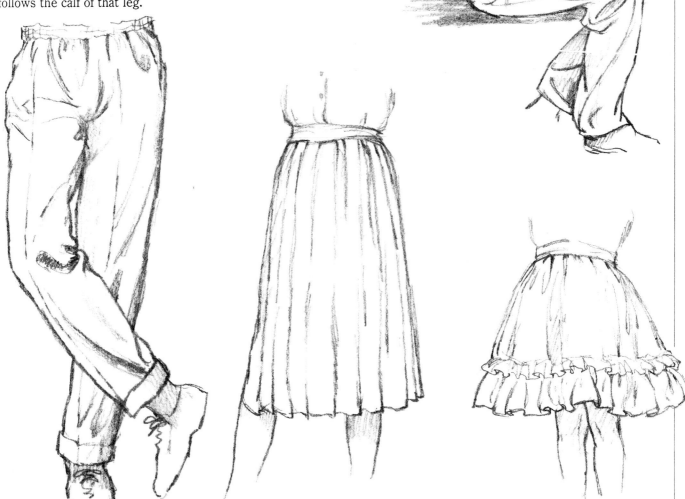

Step-by-Step: **Drawing Drapery**

This drapery study is helpful at any stage of your development. A knowledge of drapery is essential for portrait painters so that they can paint the clothing of sitters convincingly and design portraits with drama and conviction. You will also use this knowledge when depicting background drapery such as a cloth over a table or a curtain at a window.

Preparing the Fabric Take the 48-inch square of white cotton fabric and spread it out flat on a table or the floor. You'll need a yardstick and two markers with wide nibs, one colored and one black. With the colored marker make three parallel lines across the fabric dividing it equally into four parts. Make one line a solid line, one line of dashes, and one of dots. Turn the fabric in the

other direction and do the same with the black marker. The lines will cross each other at right angles.

Making the Drawings You'll want a middle-value toned paper large enough to make nearly life-size drawings of the fabric arrangements. The brown wrapping paper sold on a roll 36-inches wide has a pleasant tooth and will do the job well. You'll also need soft and medium-soft charcoal for the shadows, and white chalk or white pastel for the highlights. The brown tone of the paper will serve as the halftone. You will need a board large enough to support the paper, at least 30″ × 40″, and an easel, or you can tape the paper directly to the wall and work on it there.

Try making at least one study of each of the four hanging fold arrangements

on page 68. The lines you've drawn on the cloth will help you perceive what the fabric is actually doing. Every fold has a minimum of three surfaces, i.e., the top plane, the left side plane, and the right side plane. These planes will be easier to see if a single light source is used, such as light from windows on one side of the room or a spotlight.

Work hard to keep your drawings *simple!* It's so easy to get "lost in the folds" when your rendering becomes too intricate. If you begin to feel confused, get away from the work for a few minutes, or check in your mirror, observing the draped fabric and your drawing at the same time.

Spray your drawings with fixative when you're finished so they won't smear.

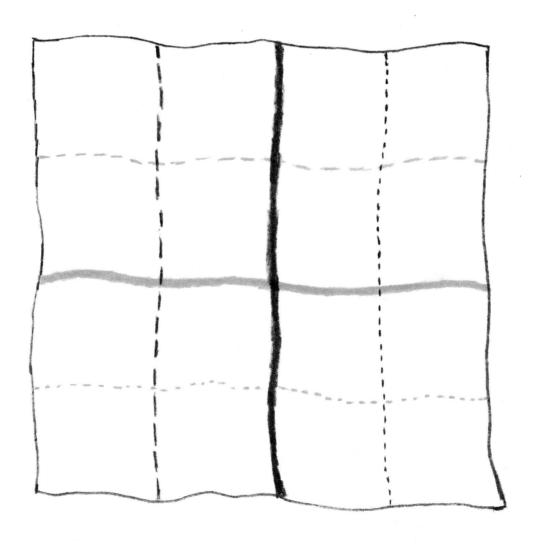

Painting Drapery Without the Sitter

The Stand-in When Britain's Queen Elizabeth has her portrait painted, which is frequently, she must of necessity have another person pose in her place while the artist paints the clothing and the jewelry. This is an excellent method for getting the job done when a very busy person is your subject.

The Lay Figure Many portrait painters borrow the clothing from the subject and drape it on a "lay figure"—a lifesize mannequin or a dressmaker's dummy—as a substitute for the real person. This not only relieves the client from all that posing, but the lay figure doesn't move, so the folds (and the light on them) are always the same.

Most lay figures in artists' studios are department store display mannequins and can be arranged to sit or to stand. Some even come with two sets of arms to allow more variety in the poses.

My own work is usually done from life in the home of the client. But to save my subject many hours of posing while I work on the clothing, I stuff the garment with a bed pillow and smaller pillows for the torso; when necessary I also use rolled towels inside the sleeves for arms. I then prop up my "figure" on the same chair as in the portrait and can work as long as I like on the folds and the pattern of the fabric.

Interpreting Drapery The Greek and Roman artists sculpted drapery as if it were wet fabric, in very vertical pipelike forms. In the works of Albrecht Dürer and other artists of the Middle Ages, the fabric appears crisp, and the folds are squarish and angular.

Peter Paul Rubens painted drapery in large round forms and influenced the Baroque painters. Two of the best to study for drapery are the eighteenth century artists Giovanni Battista Tiepolo and Antoine Watteau. The sculptor and painter Giovanni Lorenzo Bernini, who worked in Rome from 1605 to 1680, made marble look like the airiest of fabrics billowing on the wind!

In the drawing below left, after Lorenzo di Credi, a Renaissance artist, the figure appears to be nearly flying in the wind. The motion and emotion in this tiny study are created solely by the handling of the drapery. We know the drawing is fantasy from the artist's knowledge and imagination, for no one could ever see fabric moving this rapidly, let alone draw it. But the illusion is complete. Try a portrait one day of a figure outdoors, hair and maybe scarf blowing in the wind. Wouldn't this be a challenging project?

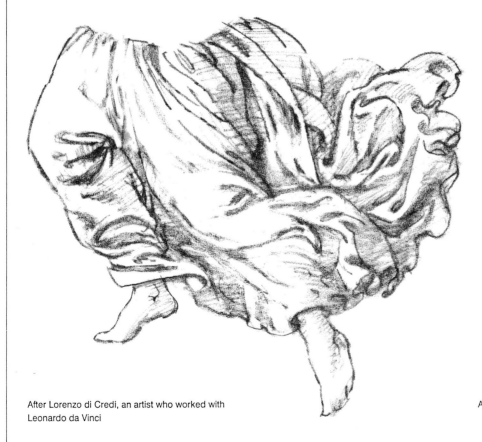

After Lorenzo di Credi, an artist who worked with Leonardo da Vinci

After Dürer, a self portrait at age 13, drawn in 1484

LIGHTING FOR PORTRAITS

The way you pose your sitter in relation to the light source has a great bearing on the look of the finished portrait. When posing your model, lighting is the first thing to consider. I almost always use natural daylight or daylight supplemented by artificial light. I personally find it impossible to paint flesh tones at night when the only source of light must be artificial, though that doesn't mean all artists find this so. Of course, artificial light is fine for charcoal portraits, where color is not involved.

Before you begin to paint or draw, try having your sitter pose with several different lighting arrangements and in different positions. Usually one place and one pose will prove to be so obviously more interesting or beautiful than the others that you can hardly wait to paint it. Of course, that's the one to choose!

On the following pages you'll find examples of various poses of the head and ways of lighting it. Draw these photographed heads, then try to simulate these poses and lighting conditions on your own, with a model, and make light and shadow sketches of each of these. You will learn a lot from this. And here's your chance to draw forty-four more heads!

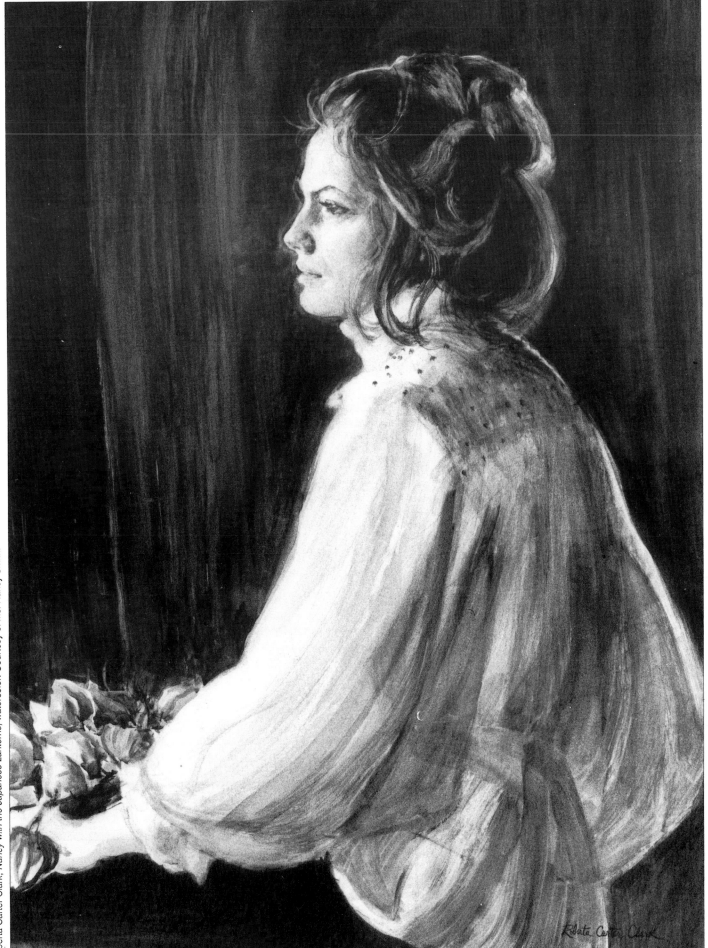

Lighting the Front View

For this lesson you'll need someone to pose for you. Your drawing materials include paper, a soft pencil (perhaps a 6B), a kneaded eraser, and some sort of portable spotlight such as a clamp-on type or a photographer's light and stand, or even a table or floor lamp with the shade removed. A 200-watt light should be sufficient. Draw your model in the kinds of light discussed here. He or she should be looking straight at you.

A word of caution: When using artificial light as a supplementary source of light, be extremely careful not to get "crossed" lights — that is, one light coming from the left and another of the same brilliance from the right. Should you ever find yourself in this crossed-light situation, I'm certain your work will end in complete frustration. Remember, one source of light *must* dominate. Make sure the second light is not as bright as the primary illumination.

Rembrandt lighting: The lamp is at about ten o'clock, slightly to the front. A triangle of light appears on the cheek *away* from the light source. This type of lighting describes form very well.

Overhead light: This makes large dark holes for eyes and is most unflattering. Often an overhead skylight creates this effect. Very satisfactory, if you like a *spooky* effect!

Sidelight: One side of the head is in the light, the other side is in shadow. Highly dramatic, but unsuitable for natural-looking portraits.

Backlight: This creates a silhouette — it's what happens when the model is in *front* of a window. Backlight could be interesting to use if some light were reflected back into the face with a mirror or a piece of white cardboard.

Three-quarter backlight: This rim light effect is interesting for unusual faces, but too harsh for some. It's not for conventional portraiture.

Bottom light: Turns any face into a fearsome one—you really have to see it to believe it. Try it on yourself with a lamp or a flashlight.

Frontal light: Since it's nearly shadowless, frontal light is excellent for people over thirty-five. The features are clearly described, but none of the aging characteristics are emphasized. It's also good for children, since it's best to aim for natural effects rather than theatrical ones when painting them. The eyes show very well in this light, as does soft, delicate modeling. If you stand with your back to a window, both the sitter and your canvas will be bathed in this frontal light, a good arrangement.

Lighting the Profile

Top front lighting: Positioning the light at the front of the face and slightly from above, at about ten o'clock, is a good angle here.

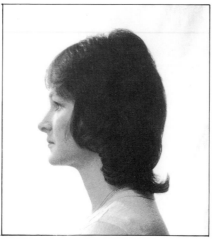

Rim light: This general, overall light coming from the front makes for an interesting profile portrait. Moving the light source away from the face creates a softer effect.

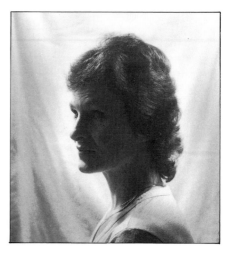

Back rim light: This really describes good features. Unusual.

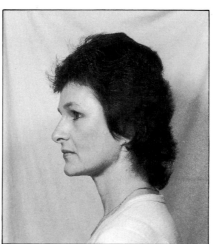

Totally frontal light: This light isn't very satisfactory for a profile portrait. The portrait always appears somewhat flat, as it shows only half the face and one eye. Frontal lighting flattens out all the forms even more.

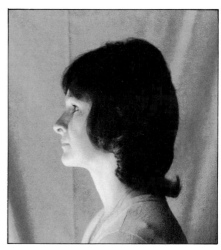

Bottom light: Scrooge and evil spirits once more!

Lighting the Three-Quarter View

Rembrandt lighting: Creating a triangle of light on the cheek of the shadow side of the face is the most dramatic and most definitive of all lighting. Here are three versions of this time-honored lighting for portraiture.

With the model seated close to the light source we get a very intense light—too intense for most portrait clients but really exciting for the painter because of the distinct lines of demarcation between light and shadow areas. This lighting is excellent for the study of solid form.

Here the model is seated a bit farther away from the light source. We get a softer light, with less contrast, but still quite good definition.

The model is even farther from the light source here, giving us a very soft, quite diffuse light. More flattering for the portrait client, more difficult for the painter because of such subtle definition of forms.

Frontal light: This light diminishes all shadows; therefore, it is most flattering for women, and in fact for anyone past middle age. It's good for children as well, particularly since I feel that children's faces are best painted without heavy shadow areas.

Rim light: This light is good used as an accent light with the general overall light coming from the front. It is often seen when the subject is near a window on a bright day.

Sidelight: Sidelight from a window works well in a three-quarter portrait and is probably what you will use most frequently.

Sidelight, face turned into the light: This lighting in a portrait looks very natural. The nose and cheekbones are well defined by mid-value shadows. Notice the highlight is on the brow bone nearest us, also on her left cheek near the nose, as well as on the nose and the lower lip. Notice the cast shadow in the background in this photograph. Some artists use this to good advantage. Of course, it is seen only when the backdrop is quite close to the head.

Sidelight, face half turned into shadow: As the face turns into the shadow, naturalness is replaced by drama. Look how the right eye attracts us, while the left eye is lost in the shadow side. This lighting is not for everyone, but would be great fun to try in a portrait of yourself. (Usually clients like to see *both* eyes!)

If the head turns even more away from the light, the hair will be brilliantly lit but the face will be in shadow. It's extremely difficult to paint the entire face in shadow. In fact, I've seen portraits by the finest painters done in this lighting that didn't work out well at all.

Lighting the Three-Quarter Back View

The only way to illuminate the face in this pose is with a sidelight, with the brightest light striking the features and defining them. This is a favorite view of Andrew Wyeth's. A portrait done from this angle always gives one the feeling that it is totally natural and unposed. It also conveys a feeling of great privacy for the sitter, for the viewer is not even considered — the sitter is lost in her own vision, her own thoughts.

A Final Word

After you've been working for some time, make a conscious effort to vary the lighting schemes in your portraits. Some painters use the same light direction in all their work, and this sameness has a tendency to make all the portraits look alike.

If you want the person to appear as if he were outdoors, try using a diffuse light. There are two ways to diffuse the light. It can be placed farther away from the subject, or a diffusing shield can be placed over the spotlight. In nature, the light comes from the sky but it is reflected in a hundred ways; it is a flattering light for people of any age. Almost all portraits with outdoor backgrounds and light were actually painted indoors. Try painting your subject in the open air just one time and you'll know why. The flickering of light through leaves constantly moving in the breeze, the lights and shadows on the face changing every half hour as the sun moves across the sky — all this makes your job extremely frustrating.

We all know that direct sunlight throws sharply defined lights and shadows on the face and also forces the sitter to squint! Brilliant sun is hard on the sitter and hard on the painter. However, if you decide you absolutely must try it — and you should — be sure to keep the sun off your canvas or paper when you are painting. It's impossible to judge the true color of things when the canvas is reflecting sunlight back into your eyes. The same rule applies to landscape painting. However, you must realize the more landscapes you paint outdoors, the more convincing the "outdoor daylight" in your indoor portraits will be.

Sidelight: This looks as if the model were seated beside a window, looking out.

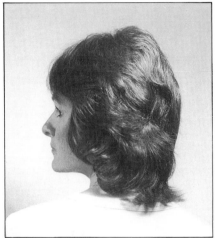

Top light: Since the face is in shadow, you need to use a light background with this kind of lighting. I would guess this view in this light gives the ultimate in subtlety and mystery to a portrait.

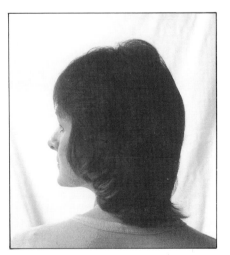

Backlight: Some light here is also reflected into the face. This is what happens when the model is in front of a window, an interesting effect but tricky for the artist who must look against the light.

WORKING IN CHARCOAL

I recommend charcoal for your first portraits with a live model. They are simpler to do than a portrait in color, because you're working only with value (light and dark) and line. On the other hand, there's no color to "pretty up" the finished portrait, so your knowledge is visible for all to see. Above all, please don't dismiss charcoal as a trivial medium. It has been the sketch and study medium since prehistoric man drew his animals on the walls of the Altamira caves.

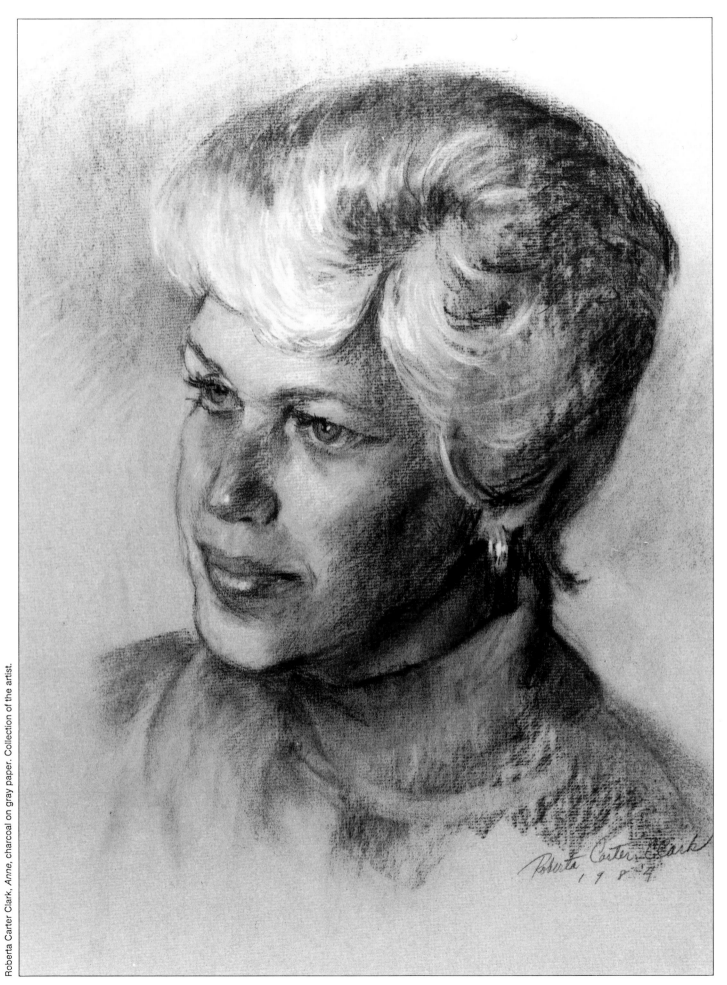

Value 1: White

Value 2: Light

Value 3: Mid-light

Value 4: Mid-tone or Medium

Value 5: Mid-dark

Value 6: Dark

Value 7: Black

Values for Charcoal Portraits

It is obvious that charcoal drawings have no color; they are in black and white and many variations of gray. For portrait painters, these variations from white, through the grays, to black, are organized into a system of "values."

Some artists paint with a system of five values, some with nine values. Here we use a simplified system of seven values, which you see along the side of this page. White and black are not really used except as accents. Therefore we are working in a narrow range of 5 values: light, mid-light, mid-tone or medium, mid-dark, and dark. The seven values have been placed on the edge of the page so you can hold your own work alongside them for comparison. Squint your eyes and look through your eyelashes at both the chart and your work. It's much easier to determine value relationships with your eyes half closed.

Bands of Value Across the Head

The rule of thumb when painting a head, whether in black and white or in color, is to have *three values in the light* and *one value in the shadow*. If the light is high and from the upper left, the lightest value—where the light is most intense—is the band across the forehead. The second lightest is the band across the cheeks, nose, and ear. Third lightest is the band across the chin and jaw. All these values are in the light.

Light and Shadow on the Head

We would use values 2, 3, and 4 for the light on the head of a person with a light or fair complexion. Someone with a medium-toned complexion would still have three values in the light but all three would be pitched a bit lower. As the complexion becomes darker, however, the values become closer together; a very dark-skinned person may have only two values in the light areas of the face. The shadow on a fair person would be value 5½. The shadow on the face of a medium-toned and a dark complexioned person would be value 6—dark, *never* value 7—black.

Highlights on the Head

The highlight on any area of the face is half a value lighter than the general value of *that area*. This means the highlight on the chin can never be as light as the highlight on the forehead.

The highlight on any area of flesh is *never* pure white. Pure black (or colors mixed to the value of black) is used only as accents. No shadow on any head is ever the black value, no matter how dark the complexion.

For changes in small forms such as eyelids, noses, and mouths, the top planes in the light are half a value lighter in light areas and half a value darker in shadow areas.

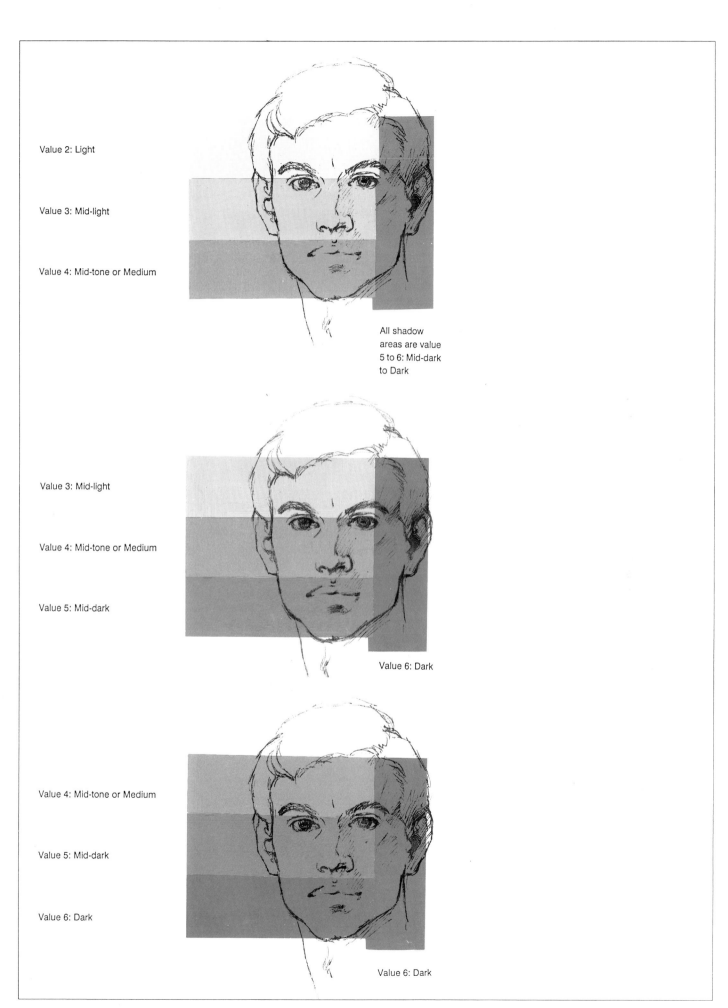

Value 2: Light

Value 3: Mid-light

Value 4: Mid-tone or Medium

All shadow
areas are value
5 to 6: Mid-dark
to Dark

Value 3: Mid-light

Value 4: Mid-tone or Medium

Value 5: Mid-dark

Value 6: Dark

Value 4: Mid-tone or Medium

Value 5: Mid-dark

Value 6: Dark

Value 6: Dark

Setting Up for Work with a Live Model

These are ideal working conditions and won't always be easy to arrange, but it's worth a try. If you're comfortable, the portrait will have a better chance of success, no matter what medium you're working in—charcoal, oil, or watercolor.

You should work standing. Do whatever you can to get the sitter's head up or down to your eye level. You could seat the model on a high stool or on a chair on a model stand. A model stand is a platform about 15 inches high and at least five feet square to allow room for the chair and a screen or backdrop.

Background The backdrop helps eliminate distracting and confusing shapes and colors behind the model. Later in your career, you'll choose a particular color, texture and pattern to enhance your sitter's coloring and costume, but for now use a plain, light colored fabric in a neutral shade draped over a folding screen or taped to the wall.

Lighting If you are working in a room with good daylight, move the model until you get the light you want on the face. If there's only artificial light, you may need lamps or a spotlight. Place the easel next to the model, as close as possible. The light should be the same on the model's head as on the work. Make sure the model doesn't cast a shadow on the portrait, and that the painting doesn't cast its shadow on the model.

The "Looking Spot" Mark a line on the floor about eight feet in front of the easel with masking tape. You will look at the model only from this spot, never when you are up at the easel. Squint so you see only the larger forms, no details, and make your decisions about what to do next at this distance—then step up to the easel and paint. Working this way, you'll get far less distortion in your portrait. In a class situation, step back a few feet, turn around, and check the painting often in a hand mirror. As a drawing aid, the mirror is very helpful, because it doubles the distance between you and your work and also reverses the drawing, giving you a new look at it. Leonardo da Vinci wrote "You should take a flat mirror and look at your work in it . . . and you will be better able to judge its errors than in any other way." Set your drawing or painting materials out on a table or taboret back at your looking spot, on your right or left, whatever side is most comfortable for you.

Timing the Pose Let the model rest for five minutes after every twenty or twenty-five minutes of posing. You need the break, too, to move around and look at your work from a different perspective. Set a kitchen timer and place it so that the model can see it—then you need not watch the clock. A word of advice: Try not to develop the portrait head when the model isn't posing; this can lead to disaster!

Understanding the "Looking Spot"

Here we see the artist standing 8 feet back from the easel at the "looking spot." The model is seated on a high stool so that her head is on the eye-level of the artist. The paper or canvas is on the easel, and the crossbar of the easel is adjusted so that it is supporting the painting surface at the same height as the model's head. Having the paper or canvas at the same level as the head of the model allows the artist to visualize the head on that surface. The easel is placed just next to the model and on the same plane, meaning not in front of the model nor behind the model.

You will walk back and forth from the "looking spot" to the easel many times in the course of the portrait drawing or painting.

8 FEET

Step-by-Step: **Charcoal on White Paper**

Materials For this exercise you will need white charcoal paper. The paper needn't be heavy, but it must have some "tooth" (texture) to it; smooth paper doesn't accept charcoal well. Strathmore 500 charcoal paper is widely available, good quality, and is 19″×25″, a good size for a life-size portrait head. Other good charcoal papers are Canson Ingres, and the heavier and slightly more expensive Canson Mi-Teintes. You'll have better results with two extra sheets under the working sheet to act as a pad.

You'll also need: two sticks each of medium and soft vine charcoal; charcoal pencil (soft or 6B); kneaded eraser; drawing board (a rigid surface is important here — use a wooden or Masonite board 19″×25″ or larger); tacks, masking tape, or clamps (to fasten your paper to the board); easel; old towel or paper towels to wipe your hands; hand mirror; spray fixative; and a kitchen timer.

Preliminaries Tape or clip the charcoal paper to the board. Break off a two-inch piece of soft charcoal, and holding it on its side, cover the entire sheet with long broad strokes. Then smooth the charcoal with your fingers so the whole sheet has a middle tone (about value 4). Rub it in enough so it won't disappear when you blow off the excess charcoal dust. It need not be an even gray, just not too streaky. Indeed, some tonal variety adds to the interest. If the overall tone is too dark the lines of your drawing won't show clearly and your work will look messy. Yes, your hands will be very dirty; wash now before proceeding.

Set up for work as described earlier, and set the timer for twenty-five minutes. Pose the model looking straight at you, full face, head not tilted. Have the light at the upper left front, similar to Rembrandt lighting.

Portrait Demonstration
I rub soft charcoal over the white paper to a value 4 mid-tone and smooth it in with the fingers a bit.

Blocking in the Head Adjust the easel so the center of the paper is the same height as the model's head. Step back to your looking spot and try to visualize the head on the paper. Then walk up to your paper and make a mark for the top and bottom of the head. Hold the charcoal loosely at the end, not tightly like a pencil. Draw with your whole arm, swinging from the shoulder, holding the charcoal at arm's length. This will prevent your work from getting too tight too soon. Try to work life-size: 8¼ inches for an adult female head and nine inches for an adult male head.

Lightly and quickly, draw the oval of the head, then the neck cylinder. Lightly put in the horizontal eyeline midway down, then the vertical center-line.

Hint: If you have to change something in a charcoal drawing, don't erase. Just tap the drawing with your clean finger and lift off the mark, then re-draw the line where you want it. Changes can be made easily in soft charcoal.

Add the brow line and place the nose approximately halfway between that line and the chin. Of course, you must study the model when drawing the features, but the information gained from working with the diagrams and egg heads should also help you to get the features in the right places.

Looking for Darks Step back to the looking spot and squint, studying the model's head for the most obvious feature, which will usually be a dark value. It may be the hair, or the shadow on the side of the face, the eye sockets, the area alongside the nose, or the shadow under the chin on the neck. When drawing or painting we always begin with the part we are most *sure* of; this is the easiest way. Add this most obvious area to your block-in.

Work with the piece of charcoal on its side (not its tip) for a broad effect. Usually the eye shapes go in next—the whole eye cavity. They should be just dark ovals now. You're not *drawing* the eyes, just *placing* them. Remember, shadow is the area where direct light does not strike the form. Add the other shadows, squinting all the while. Don't try to perfect any features yet. (We just need to know where the darks go; we can't have lights later without darks now.)

Check your shadows by looking back over your shoulder in a hand mirror, comparing the model and the drawing. Look for and correct distortions, particularly any lopsidedness. Remember your centerline. Double-check that one side of the face is not wider than the other, a common fault.

Then turn around and compare the model with your drawing, squinting hard. With your fingertips, tap out the areas that have become too dark. Now you're beginning the modeling of the head. Wipe your hands clean before tapping out the charcoal or you'll end up just moving it around! *Don't rub,* just tap. You now have a head with half-tones (the gray tone rubbed on the paper) and shadows, but no lights.

Looking for Lights From here on, begin to define the lights and thereby refine the shadow shapes, using strokes that follow the form if you can.

Where do you see light areas? On the light side of the forehead? Surely on the light side of the hair. Under the keystone area at the bridge of the nose? On the cheekbone? The area between the nose and the upper lip? Perhaps the lower lip catches the light, and part of the chin and neck. Squint, and you'll discern those lights. If the model is wearing a white collar, lift that out now with your fingertips or a kneaded eraser. It will help you to judge the values on the face and head. Try not to get darks in the lights or lights in the darks.

To get really clean light areas, lift them with a clean point of your

Portrait Demonstration
The head is placed on the paper, egg-oval drawn, also the eye-line and the central vertical line. Brow line, nose, and mouth are marked. Head is considered "blocked in."

kneaded eraser. You really do have to *lift* – rubbing will only smear the charcoal. After each touch, when the point of the eraser is dirty, pull the eraser into another point. If you keep the eraser in the warmth of your other hand, it will remain pliant. Theoretically, the eraser should eventually become black all the way through, but in actuality you will be able to find a clean spot in it even after dozens of drawings. It takes years to wear out one of these kneaded erasers.

Your head now has lights, shadows, and halftones. You have not yet attempted to finish the eyes, nose, or mouth.

Working Out the Features

I can tell you how to draw the features, but I can't tell you in what sequence to do them. We will start with the eyes, followed by the nose, the mouth, the ears, the hair. This is not, however, the way a portrait is done. No one finishes the eyes first, then the nose, then the mouth. You have to work over the entire head. Working on the eye socket, you see how that helps you to define the temple. And working on the inner corner of the eye leads you to the structure of the nose bridge. This may in turn lead you to the bony part of the nose and then the tip of the nose, which leads you to the cheek, to the mouth and the chin. Then the artist returns to each area, refining with ever more subtle adjustments until all the parts come to a finish at once and the portrait is done.

To be truthful, one feature will lead you to another, but I can't write a book that way. It would be far too long and confusing. And so, for the sake of clarity, I will cover the features one by one.

Before you draw, it seems sensible to read through the following material from eyes through hair and then refer to it as you need it. Drawing a charcoal portrait is just like any other activity. The first time you'll be awkward and may return to the information frequently, but as you get to your eleventh and twelfth portraits you'll develop your own rhythm and sequence, and will only have to refer to these pages when you get stuck.

Work in any order you like, just so that you develop each feature as well as you can and relate each one to the others. Remember, every approach is valid and will produce excellent likenesses.

The Eyes The entire eye area is now dark. With a pointed end of the medium charcoal, draw the upper and lower eyelids as they follow the round form of the eyeball. Then put the fold in the upper eyelid, if you see one, and draw the iris, working on both eyes at once. Please don't try to finish one eye and then go to the other. It's more difficult – and they may never focus!

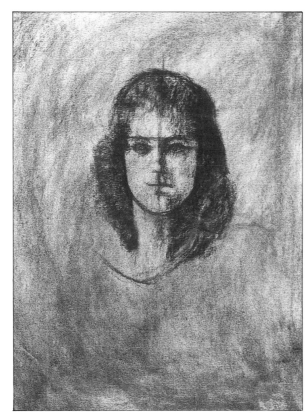

Portrait Demonstration

After squinting, darks are added first in the hair, then the eye ovals, alongside the nose, the upper lip, under the lower lip, and on the neck.

Molding the kneaded eraser into a point, lift out the whites of the eyes where you see them out of the midtone and darks. Remember, the whites of the eyes are not *white*, for they are shadowed by the eyelids. If you make them too white, the eyes appear to be staring.

Now add the dark pupils and any other darks you see in the eyes. Pick out any light area on the upper and lower eyelids, then work out the shadow between the inner corner of the eye and the nose, watching for a light at the area near the tear duct. Look for the shadow under the lower lid.

Perfect the eyebrow, looking for a light spot as it follows the bone over the eye socket. Remember the eyebrow is made up of tiny hairs; draw it in many short strokes. Look at the model's eyes up close and study the eyelashes and add a few of them very delicately—not a whole series of tiny lashes like a centipede's legs.

Lay your stick of charcoal horizontally across the eyes on your drawing to be sure they're level. It's only too easy to get them out of line when you're working on them bit by bit.

Then, form your kneaded eraser into a clean point and deftly pick out the highlights in the eyes, at about ten o'clock if the source of light is at upper left, about two o'clock if at upper right, or where you see them. This highlight should be *small*—a great white spot cheapens your work. You *have* to do this last, because the focus of the eyes is achieved by minute adjustments between the pupil, the iris, and the highlight, and you can't handle this with any real finesse until the head is virtually complete. Putting in this highlight is the most fun of the entire portrait! It really brings it to life.

Hint: If the highlight you've drawn in an eye isn't right the first time, darken the area and try again. These highlights should be quite sharp and clear to indicate the wetness of the eyeball. It will never look right if you keep dabbing at it with the eraser. Clean and careful does the job.

The Nose You've made the nose mark halfway between the brow line and the chin. Studying the model, decide if the nose is shorter or longer, and correct it. Sketch in the triangular shape of the nose, the top and side planes, the ball, and the wings on either side, studying the model all the while. As you worked out the area of the tear ducts of the eyes, you may want to work out the bridge of the nose. The side of the

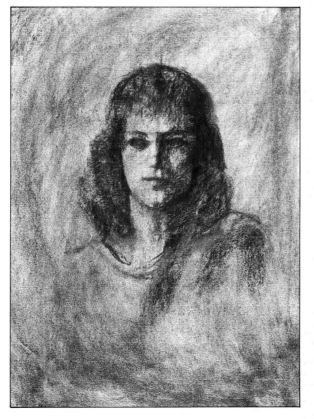

Portrait Demonstration
The lights are picked out with the fingertips or a kneaded eraser. Darks are more defined. Halftones are made visible.

bridge away from the light may be very dark, so do nothing there. But there should be a light on the bridge of the nose just below the keystone area where eyeglasses rest. Is there light on the bony part of the nose? Does the light on the side plane spill over onto the cheek? Squint hard and you'll see these lights. Lift them out with a clean point of your eraser.

Add dark to the underplane of the nose and the nostrils. This leads us to the small indentation from the center of the nose down to the bowed center of the upper lip. Is this visible on your model? Is it shadowed? Add this and the rounded shadow side of the "muzzle" area, the skin that travels over the upper teeth and curves around to meet the cheek.

The Mouth Hold your charcoal vertically at arm's length and line up the corners of the mouth with some part of the eyes, as in the illustration. Are the corners of the mouth directly beneath the pupils? Place both corners, and then the center of the upper lip. Don't forget to break the line between the lips. Put in the shadow in the corners of the mouth if you see any. Add the shadow under the lower lip, and the upper lip, which may be entirely in shadow. With the clean point of your eraser, lift the lights where you see them: just above the upper lip, on the light side of the rounded "muzzle" area, and on the lower lip—anywhere else?

The Ears Sketch in marks to indicate the top and bottom of the ears, the top of the ear at the brow line. Draw the flat oval disk of each ear at the same slant as the ears on your model. Refine the disk shapes into better ear shapes. Put in the line forming the fold at the upper rim, the helix, then the bowl, the two small flaps—whatever is visible, and the earlobes.

Look for darks in the ears. The ear on the shadow side of the head may be totally dark, with no detail discernible. Study the lights and pick them out with a clean point of your eraser. There's usually a bright light on the helix and on the lobe. You may see others.

The Hair Hair should be treated as a mass, not as lines. Lay the charcoal on its side and block in the darks. Blend the edges in at least two places where the hair meets the background, so the head doesn't look cut out and pasted on the background, but integrated with it and the air around the head. The edges where the hair meets the face are also extremely important: soften them with your fingers. You don't want the hair to look like a wig or toupee! Then squint and decide where the highlights are lighter than the halftone of the paper, if there are any, and lift them out with the eraser. Watch how the hair flows, how it falls; let your lights describe this action.

The most important aspect of hair is its *texture*. The hair on an average head consists of thousands of filaments. Nothing about hair is at all like the skin over muscle over bone that makes up the face and the body. Think of ways you can show the special properties of hair—the softer edges, linear movement, and design found in waves or curls, or its sheen. Your treatment of the hair can even help express the personality of your sitter; a person with every hair in place is very different from one with loose, flyaway hair.

Hold the charcoal vertically to align one feature with another—here, the corner of the mouth with a part of the eye. A brush or a pencil may be used when working in other mediums.

Hint: In putting in the features, no matter what the medium, work back and forth between the lights, darks, and halftones, continually refining the drawing.

Finishing Touches You now have a head with darks, halftones, lights, and well-developed features and hair. The head is integrated into the background. Look at your model very, very hard now, with your eyes wide open. Search for a few selected places where absolutely no light can reach, and firmly put in small dark accents with your charcoal pencil. These add sparkle, as do the highlights; check and add any highlights you've overlooked.

Look for reflected light under the chin or on the side plane of the lower jaw on the shadow side and lift these with your eraser. Reflected light can never be lighter than the halftone, and *never as light as your lights*. If it were, it would destroy the solid feeling of the head.

Add the collar, clean up the background with your fingers where you may have left smudges, and you're finished. You've spent at least an hour on this drawing. Anything over two hours is too long—you lose your ability to make judgments after so long a period of concentration.

Wait a day before you look again at this drawing and judge it. Correct any errors you see then, and spray it with fixative to keep it from smudging.

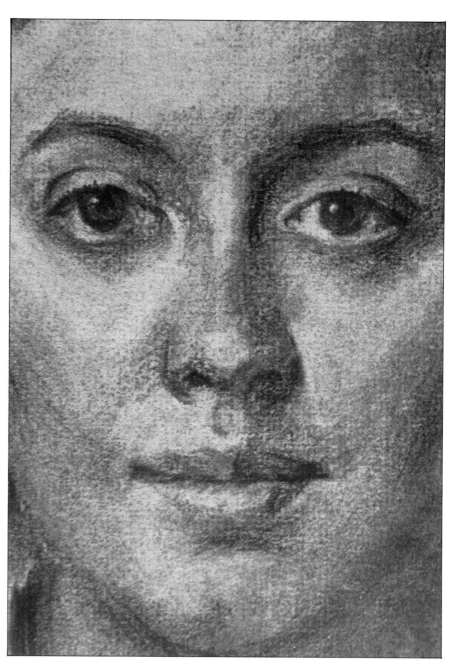

Portrait Demonstration

(Detail) Notice the degree of finish and the rough texture, or "tooth," of the Strathmore charcoal paper. Can you see how softly the linear elements defining the eyes and the mouth are handled? Can you see where the kneaded eraser has picked out the lightest lights and the highlights? And where the darkest accents are placed? We all know no portrait is ever perfect, and this close-up makes me painfully aware of an error. I think the nose tip is pulled over to the right a bit too far—do you agree?

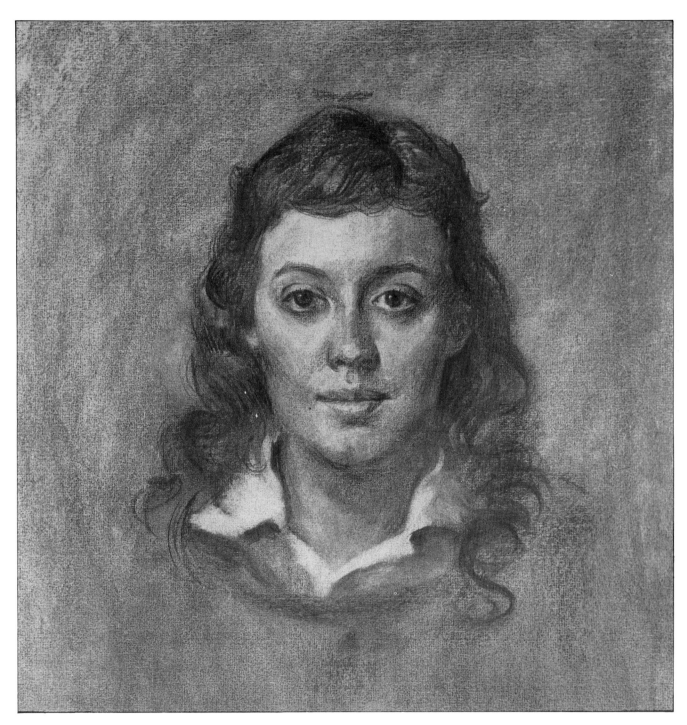

Wendy
Charcoal on white paper: 25″ × 19″

Portrait Demonstration

(Finish) Now the features are worked out. Highlights (where the eraser has lifted the charcoal and left clean white paper) and accents (deepest spots of dark) have been added. The hair edges are integrated into the background in places. Reflected lights are tapped out with the fingertips, making sure they are no lighter than the halftones. After careful checking in the mirror, I decide the portrait is finished.

Step-by-Step: **Charcoal on Tinted Paper**

We will be using the same materials as before, but working on a mid-tone gray paper, rather than white. Add a stick of white Nupastel to your supplies for bringing out the light areas and highlights.

Perhaps you would like to try a portrait in more of a profile view now. You will find the procedure is the same, but the drawing problems are quite different. Have your model turn his body to one side, but adjust the head so you can just see the other eye; this view is much more interesting to draw than a flat profile. If you're right-handed, it's easier to draw the model facing to his right (your left), and vice-versa. Also, be sure he is facing toward the light, not into the shadow.

In this charcoal technique we do not tone the paper; the tint of the paper *is* the halftone.

Placing the Head on the Paper Set the timer for twenty-five minutes and have your model pose.

Step back to your looking spot, squint, look through your eyelashes, and study the head, looking from model to paper and back again. Try to visualize the head on the paper. Decide where to place the top of the head, how it slants, and the size of the head. Then step up to the easel and, with your soft charcoal held lightly, make a mark for the top of the head, the bottom of the chin, the outside edge of the face, and the back of the head. Try not to draw the head larger than life-size.

Placement of the head is important; you don't want the head too close to the top edge, and you don't want it in the lower half of the paper either. There are no absolute rules. Later, after doing several portraits, you may want to attempt less conventional placements—even allowing the head to run off the top of the paper. We just have to learn to walk before we can run.

Blocking in the Head Now that you have the general dimensions, draw the oval shape of the head within them, studying the model. Look carefully to determine the angle of the head. Is it tilting up and back, or down, or is it straight up? When you decide, draw the eye-line halfway down, making it an ellipse, if necessary, to conform to the tilt of the head. *This line is the most important factor in establishing the position of the head.*

Add the brow line parallel to the eye-line. Sketch in the vertical line in the center of the face and mark the base of the nose halfway between brow line and chin. Add the vertical line at the side of the head and place the ear just behind it, aligning the top of the ear with the brow line and the bottom with the nose line. Place the mouth line. Indicate the hair mass. Then place the angle of the neck cylinder, front and back, and then the collar line. You now have a blocked-in head.

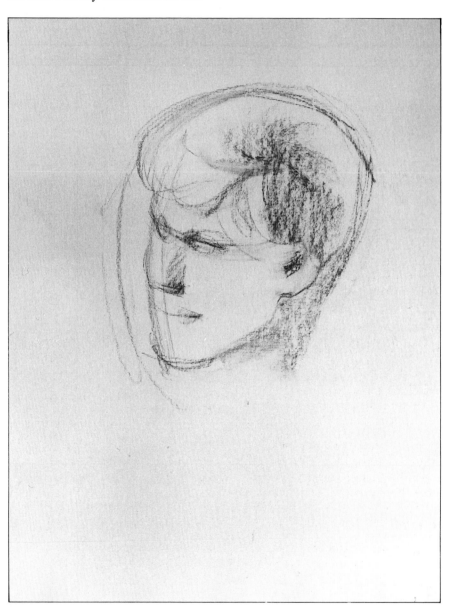

Portrait Demonstration

When placing the head in the picture area, be sure that the top of the head isn't too close to the top edge of the paper, more "air" is given on the side from the face to the margin, and less at the back of the head. The nose falls slightly above the vertical center of the paper, approximately midway from top to bottom.

Looking for Large Shapes and Darks

Step back, squint, and look for whatever shape appears most obvious. In this near-profile it's most likely the hair mass, for in this view, the face occupies a relatively small area. Indicate the hair shape. Is it dark? Now look for shadow areas in the face. First the eye socket, then the underplane of the nose, and possibly a side plane of the nose. Then another side plane at the cheekbone, the side of the face from the temple down to the jaw and chin. Lay these areas in with the side of a small piece of charcoal. Is there dark on the neck? Anywhere else?

Adding Lights, Refining Angles and Proportions

Again step back. You can't define the lights without careful attention to the edge of the face, so hold up your charcoal at arm's length so it appears to lie along the outside edge of the model's forehead. Then walk up and add this line to your drawing. Step back and repeat this process for the line of the angle of the nose, the cheekbone to the lower jaw, and along the jawline to the center of the chin. Lay all these angles in lightly. (Most artists begin with all straight lines for these indicators.) Look in the mirror at the model and at your blocked-in head at the same time to check for accuracy. Use your kneaded eraser, but try brushing the incorrect lines off with a paper towel first, or tapping them off with your finger, then blowing away the charcoal dust.

Working out the Features

We have defined the outside shapes of the nose, forehead, mouth, chin, and neck. Now we'll move within the head shape. Looking at the model, hold your charcoal stick horizontally and sight-check the alignment of the top of the ear with the brow line. Is the top of the ear higher or lower than the eyebrow? Draw the ear, using medium charcoal now for more precise drawing.

Draw the eye shape, the brow, then the bridge of the nose, the hollow at the inner corner of the eye, and the nose. Check, holding the charcoal vertically and at arm's length, how the wing of the nostril lines up with the inner and outer corner of the eye. See how far the mouth and chin project beyond the nearer brow, and sight other vertical alignments such as the corner of the mouth and the eye. Check both the model and your drawing in the mirror for all these relationships.

Finally, refine the shape of the hair and any collar area.

You now have a head with a carefully drawn near-profile silhouette, darks, and halftones. Indeed, there's nothing *but* darks and halftone, for the whole paper is the halftone.

Putting in the Lights

Now, with the white Nupastel in hand, squint very hard and decide where the lightest areas are — lighter than the halftone gray of the paper. Then *erase* all charcoal from areas where you want the whites *before* you place them. (You may want a few lights in the hair, for example.) Lay in these areas very lightly at first, and don't put in too many or you'll destroy the form of the head. You must be *sure* if the area is light, halftone, or dark shadow. Don't get any whites in the charcoal shadows or charcoal in the white pastel areas — your drawing will be really muddy.

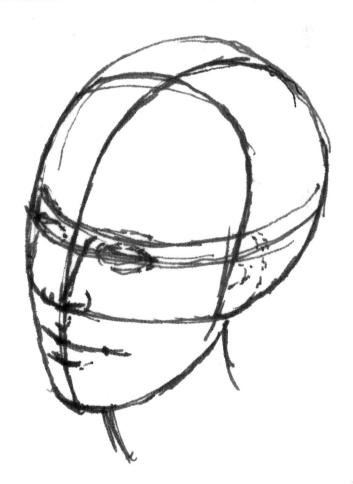

Portrait Demonstration

The head of my model, Anne, is almost in total profile and tilted. This makes the eye-line a downward ellipse and the central vertical line a way around to her right. The ear line is a quarter of the way around the head to her left side.

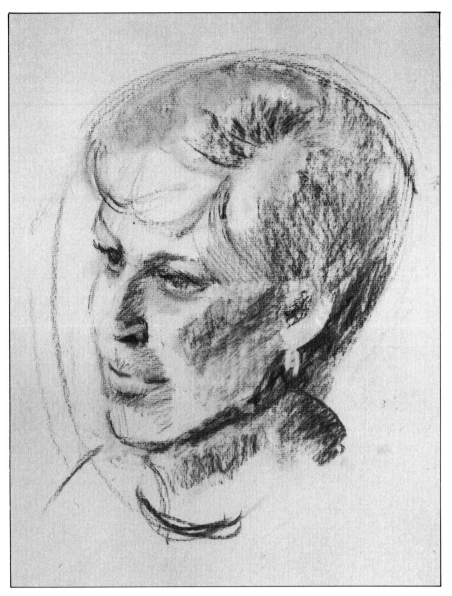

Adding the Highlights

When we were working on white paper, we let the white of the paper serve as our highlights. Now we're using tinted paper, and we've laid the light areas in with a gentle touch, but put the highlights in firmly now with the point of the white Nupastel.

Search out the highlights on the model's head—maybe at the bridge of the nose, on the cheekbone, the tip of the nose, and on the lower lip. Enjoy adding a crisp light in the eye *only* if you see one.

> *Hint:* Highlights are great fun to put in and add considerable vivacity to the portrait; keep them small and bright. The highest light is often on the forehead as it is closest to the light source.

Dark Accents and Reflected Lights

Accents could be in the iris and pupil of the eye, a dot or two in the nostril, the corner of the mouth, and in the hair. Look for reflected light under the chin and lift it out with your kneaded eraser (*no* white pastel here). Add the darks and lights of the collar. Clean up any fingerprints in the background with the eraser. You could leave the tint of the paper as your background or develop it with shadow. Having a darker background behind the light side of the face throws the head into relief.

Portrait Demonstration

With much squinting, the direction of the light is noted and the resulting shadow shapes are laid in. Angles of the features are considered. Each feature has its own distinctive shape and direction. Still, they must all work together.

This drawing should take one-and-a-half to two hours, or four posing sessions. Put it away so you can look at it tomorrow with a fresh eye; correct it then, if you need to, and spray it with fixative.

Comparing the Portraits

My portrait of Wendy (on page 91) is what's known as *painterly*—it looks as if it were done with a broad brush rather than a pointed drawing instrument. The lights, shadows, and half-tones are quite developed, giving it a feeling of solid mass. Line does not play a large part in this work.

This portrait of Anne, on the other hand, is more *linear* and less "round" or sculptural. This may be partially because Anne is in a semiprofile pose, which can look quite flat. However, many artists believe it's easier to get a good likeness with a profile. Putting a darker background behind the face sometimes helps throw the head into relief, but a sharp contour line around the face and head may make it look pasted on the background. Varying the weight of your profile contour line, making it lighter where direct light strikes the form and heavier on the shadow underplanes, should help the head to appear more rounded. Softening the edge of the hair shape in at least two places and allowing it to blend into the background also helps.

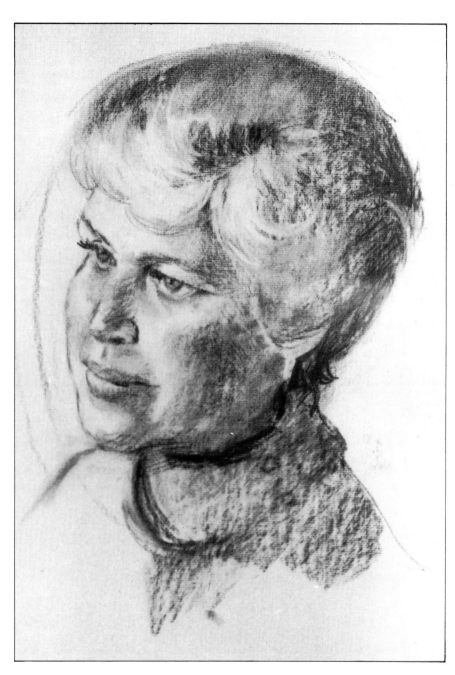

Portrait Demonstration

I refine the features, and the head and hair shapes. Small darks are added and lights lifted out. I was so busy working on the features that I lost the likeness—very easy to do when looking at the parts and not the whole. It looks like a round-faced, even chubby, person; not like Anne. Did she move her head a bit? Did I change my viewing position?

I decide the neck edge of the turtleneck sweater is too straight and force the line to become a rounded ellipse like the eye and brow line. Notice how the right and left eyes differ.

Anne
Charcoal on gray paper: 20″ × 16″

Portrait Demonstration

(Finish) After considerable effort, Anne's character begins to emerge again. The delicacy of her head is a very important part of the likeness. I've done and redone the line defining the far side of the face, a very tricky area in a head turned away this far. After much checking in the mirror, I lift out the charcoal and put in the highlights with white Nupastel. I add a few dark accents in the pupils of the eyes, at the bridge of the nose, in the corners of the mouth, under the chin, and behind the earring. The expression is true now.

I decide the turtleneck is still too heavy. I really don't like turtlenecks for portraits very much. They cover the neck right up to the chin and, to me, separate the head from the body. I change it to suit myself. A slightly darker value is placed behind the white hair at left and also at right to make it look as if the tone is behind the head, giving the illusion of a three-dimensional head.

Two hours and fifteen minutes have passed, five posing periods. I sign and date the drawing and spray it with fixative.

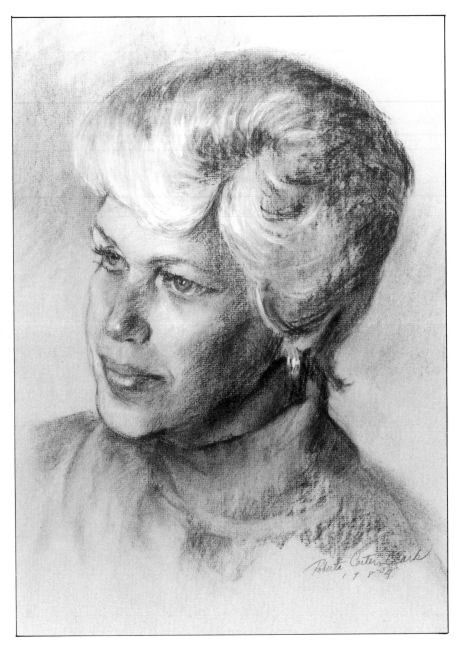

Portrait Demonstration

(Detail) Note how softly the edges are handled; there are no hard lines defining the far side of the face, and there are none around the mouth. The white highlights are kept to a minimum.

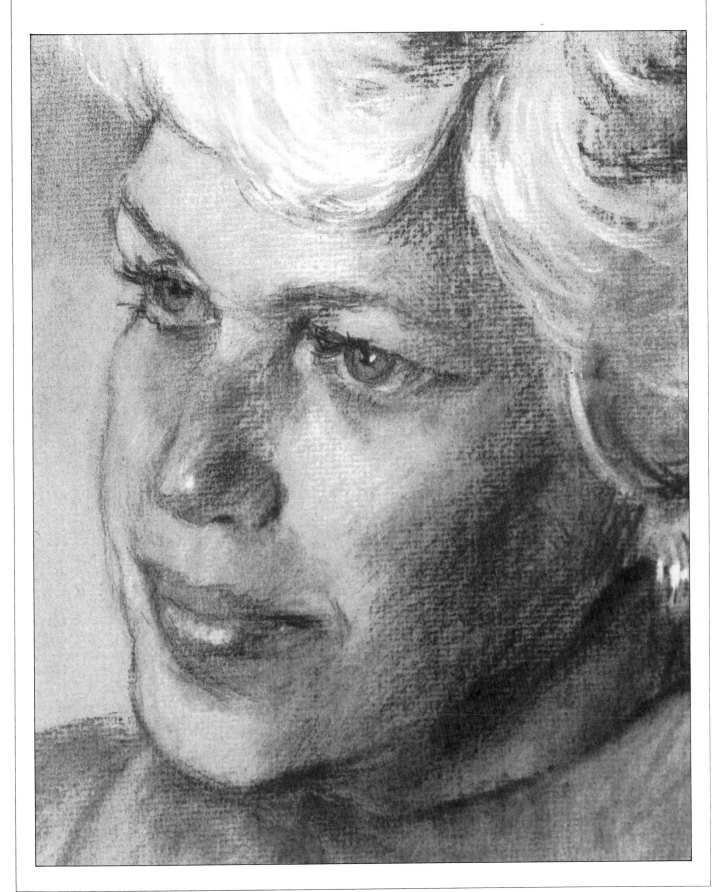

Other Approaches to Charcoal Portraiture

The painterly approach of Wendy's portrait and the more linear approach of Anne's portrait are not the only two ways to handle charcoal. Other artists use the medium differently, as you will see in the examples that follow.

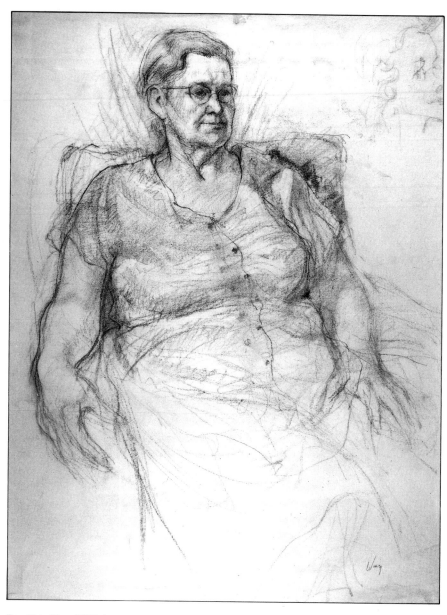

Ronald L. Wing (1929-)
Paul's Mother
Charcoal: 24″ × 20″
Collection of Roberta C. Clark

The emphasis here is on line rather than values. Almost all the definition in this work is in the light side of the body, with an absolute minimum of description telling us all we need to know. You can see where Wing changed his mind about the center front of the dress. I think the line he chose describes the torso better, don't you?

The head is beautifully done—the ear is marvelous—but the solid form of her right arm—the extremely subtle foreshortening and the distortion that makes the wrist and hand project—proves Wing is a sensitive artist.

In Degas's masterful black chalk drawing for a portrait of his friend Manet we again see a more linear approach, but also an interest in pattern. The dark beard, hat, and shadow under the sleeve keep our eye moving over the entire figure. Every part of the figure—from the set of the shoulders, to the hand, to the heel of the shoe—has received careful attention, with only slightly more given to the head. Note the descriptive strokes going across the form on the head and face. There is no flash or dash here, just a sure and competent drawing by a true genius exploring an idea. You can see where he changed his mind about including the walking stick and a different view of the hat. Notice too how Degas has handled the hair as it grows from the scalp, and the beard and moustache as it grows from the face. The beard never looks woolly; it looks like hair.

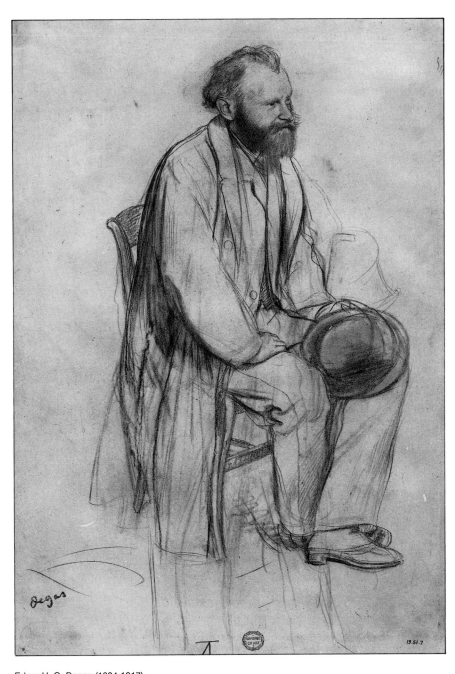

Edgar H. G. Degas (1834-1917)
Study for a Portrait of Edouard Manet
Black chalk: 13″ × 9⅛″
The Metropolitan Museum of Art, New York
Rogers Fund, 1918

Lilian Westcott Hale uses charcoal in a highly personal way, building up the figure in countless vertical strokes. With admirable restraint, she consistently says more with less. The dress is simple and the hair not overly defined but kept as a textured mass. Notice how she emphasizes the little girl's fragility through the delicate shadowing and also by the shock of the very black background against the child's fair hair and skin.

The small hands add so much. Aren't they wonderfully child-like? Although the child's dress suggests this portrait was drawn in the thirties, the way Hale has allowed the head to go out of the picture, the positioning of the figure, and the contained dark shape on the paper give hints of a more contemporary approach to children's portraiture.

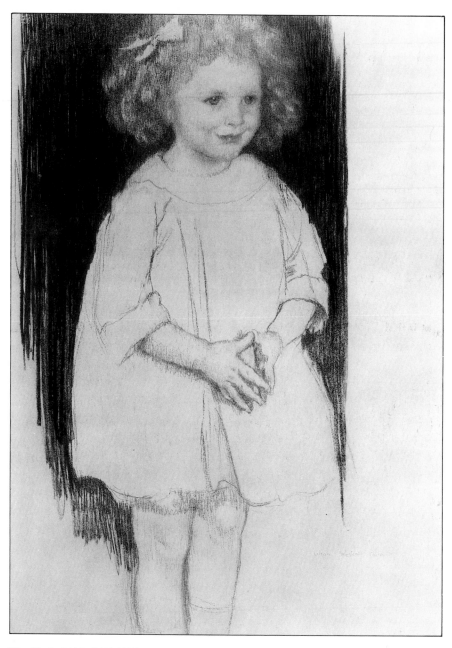

Lilian Westcott Hale (1881-1963)
Little Girl
Charcoal: 29⅛" × 23"
Private collection
Photograph courtesy of Hirschl & Adler Galleries, New York

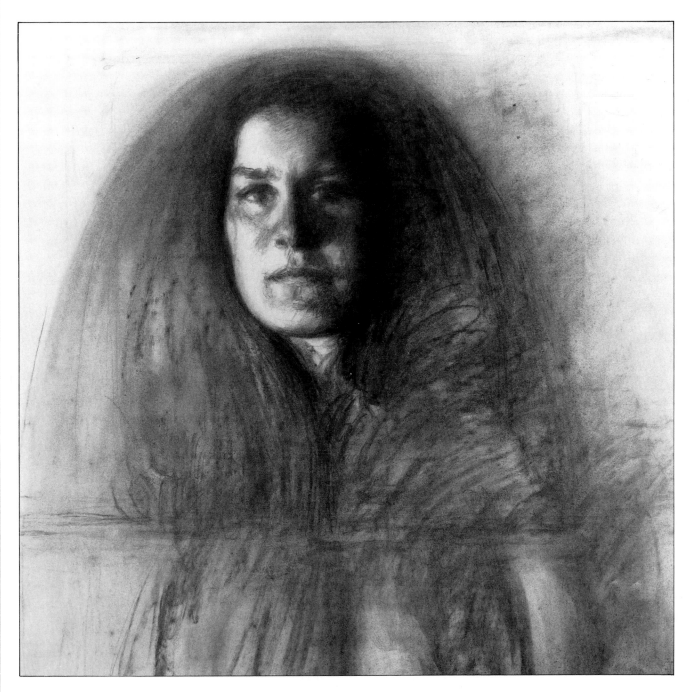

Sidney Goodman's unconventional approach to charcoal portraiture comes more from the unfinished quality than from the actual drawing style. The head is treated in a painterly manner, and the values in the face and hair are strong and extreme!

What makes this portrait contemporary? Is it the focus on the face and hair, allowing the outside contours to be less defined? Is it the way the hair is generalized into a compelling shape? Notice he held the edge of that half-oval shape against the background on the light side of the head and allowed it to diffuse into the background on the shadow side.

Goodman considered ending the portrait at the horizontal marks just below the shoulders but changed his mind and decided not to trim it away. When I look at this portrait, I feel the strength of the characterization, almost a sense of confrontation with this young woman. Goodman has made her anything but remote or detached.

Sidney Goodman (1936-)
Portrait of P (1978)
Charcoal: 24" × 29"
Courtesy of Terry Dintenfass, Inc., Gallery, New York

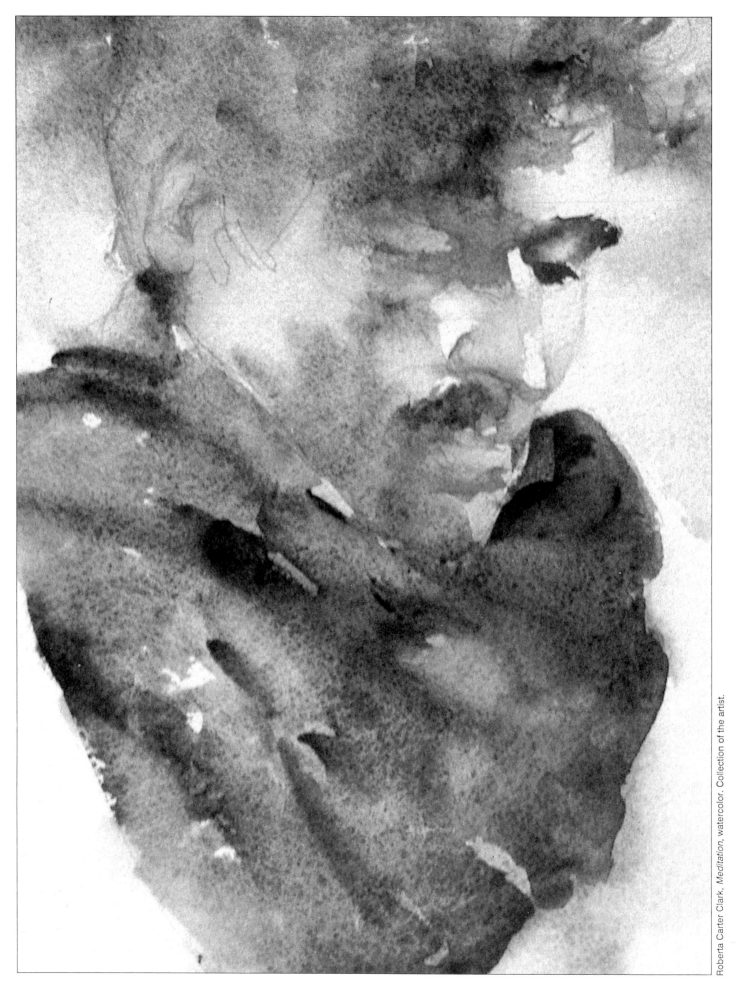

Roberta Carter Clark, *Meditation*, watercolor. Collection of the artist.

USING COLOR

You'll need to know something about color before moving on to paint portraits in oil and watercolors. What you've learned from charcoal portraits will be useful. You now know about modeling the form, distinguishing the lights from halftones and darks; you are aware of soft and hard edges, and ways of handling texture. But when we work in color we add another facet to the problem. Of course, we also add excitement!

The perception of color is such a personal experience. Each of us sees colors differently, influenced by associations from as far back as childhood, by preferences for what we think is beautiful, by the sharpness of our vision, and by the possibility of some color blindness. Our reaction to color is psychological and even visceral—there can be no question that color affects the emotions.

In this chapter we will develop a vocabulary so we can discuss color intelligently in the ensuing chapters on color techniques. You'll find four projects here that use color in ways to help you understand it better and feel more confident about mixing the colors you want. Then we will be ready for flesh tones and hair mixtures.

Step-by-Step: Color as Hue

Hue is the *name* of the color: red, yellow, orange, purple. These words describe a *hue*.

Red, yellow, and blue are considered *primary colors*. To mix any color you must start with one or two of these three, for you can't mix red, blue, or yellow by combining other colors.

We are going to make a color wheel, which will give us the know-how to mix the three primary colors into fifteen more, plus a neutral gray. We'll learn to find harmonious or dramatic color combinations and how to neutralize one hue with another.

Materials You will need lemon yellow, alizarin crimson and cobalt blue oil paints in tubes, plus the following materials: a disposable paper palette, 12″ × 16″, for oils; a ball-point pen; a flat square brush (called a bright) about ¼″ wide — not bristle, but softer — synthetic sable is fine; palette knife; gum turpentine or odorless paint thinner in a homemade brush washer (see instructions at right); paper towels; and Winsor & Newton Liquin Oil Painting Medium.

Note: For all the charts in this chapter done on the disposable paper palette, we will add a few drops of Winsor & Newton Liquin Oil Painting Medium to our paints to speed the drying process, which will be about two days under normal drying conditions.

Making a Color Wheel

Squeeze out about an inch of oil paint of each color along the top edge of the paper palette: lemon yellow (left), alizarin crimson (center), and cobalt blue (right). Carefully tear off this palette sheet and tape or clip it onto a white paper or cardboard. (You'll be mixing color on this sheet throughout this chapter.) Using a ballpoint pen, trace this color wheel illustration onto the *next* top sheet of the paper palette. You'll be painting on this sheet: The waxy surface is perfect for oils — they spread easily and look beautifully clear, like stained glass, and the oil from the paints won't leave the oil stain you'd get on paper.

With the flat brush, paint the primary hues in the designated areas on the

Making a Brush Washer

An excellent brush washer can be made by taking an empty tuna fish can, punching nail holes all over the bottom of it, putting it upside down in an empty one-pound coffee can, and filling this can about one-third full with turpentine or odorless paint thinner. All the sediment filters to the bottom of the coffee can, so the turpentine on top is always clean. Hammer the nail holes from the outside in, that way the rough metal edges are on the inside and your brushes will not be ruined. Keep the plastic lid on the coffee can when you're not using it so the turpentine doesn't evaporate. You can use the same cans for months, depending on how often you paint, until the turpentine no longer clears upon standing or the dirty paint sediment oozes up from under the holes. Then just throw the whole thing out and make a new brush washer. No cleaning out the mess! The brush washer is also good for painting outside your studio; just don't spill it! (A word of caution: the coffee can must be metal or it will leak.)

Washing your brushes with soap. No matter how clean your brushes are when you have rinsed them in turpentine or paint thinner, you still should wash them with soap and water at the end of every painting day. Wet the brush, scrub it into a cake of soap, then scrub the bristles in the palm of your hand. Rinse in warm water, squeeze out the excess water and shape the brush with your fingers and lay it flat to dry overnight. If you can get into the habit of washing your brushes, they will last longer and respond better.

color wheel you have traced. Remember to wash the brush clean in turpentine before each new color, wiping it on a paper towel until no color comes off. You can mix your paints with a palette knife if you wish; just wipe it clean between colors. Add only a drop or two of Liquin Medium to make the paint easy to apply; it should be thick and buttery so it covers well.

When you've done the primaries, paint in the secondary hues. For green, start with lemon yellow and add cobalt blue a bit at a time; you'll have to make several mixtures to get a green not yellowish, not bluish, but halfway between. Again starting with lemon yellow, add touches of alizarin crimson

until you arrive at an orange which is halfway between yellow and red. Repeat this procedure adding alizarin to cobalt blue for a purple hue halfway between the two. Paint the three secondaries in their spaces. Do your best to keep the edges of each hue from mixing with its neighbor.

Then mix the tertiary hues. Put a bit of alizarin crimson into the orange mixture and mix until you get a red-orange (halfway between red and orange). There will be five more tertiaries to mix: yellow-orange (lemon yellow plus orange), yellow-green (add green to lemon yellow), blue-green, blue-purple, and red-purple. Paint each mixture in its proper place. Then mix the

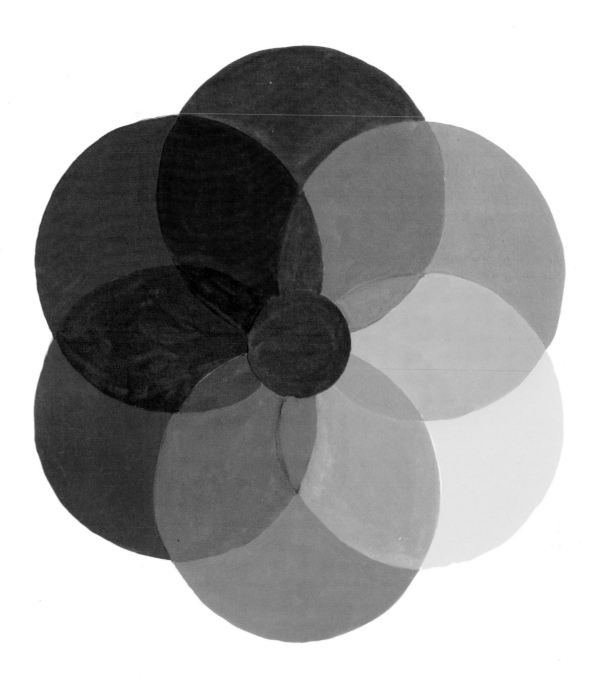

quaternary hues from the tertiaries: russet, dark orange, citron, dark green, olive, and dark purple, using the same procedure.

When you're finished, mix together whatever is left on your palette for a neutral no-color and paint this in the center circle.

After it dries, tape your color wheel to white paper or board so the colors will appear more solid, then tape the wheel on the wall of your studio or inside the lid of your paint box where you can see it and use it often enough to commit it to memory.

Working in Watercolor Trace the color wheel above and transfer it onto watercolor paper. Squeeze alizarin crimson, lemon yellow, and cobalt blue (from tubes) onto a watercolor palette or a dinner plate, leaving room for more colors to be added later on. Fill in these primary hues first, then the secondary hues, mixing carefully to get a green halfway between yellow and blue, an orange halfway between yellow and red, and a purple halfway between blue and red. Allowing each wash to dry before applying the one next to it, mix and fill in the tertiary and quaternary hues. Finally, mix yellow, red and blue for the neutral gray in the center.

Hint: Notice that the more hues you mix together, the less clarity and brilliance you have. Remember this later when you are painting portraits. Try then to get the hue you want by mixing only two colors (not counting black or white) or possibly three. Any more will give you mud, and the color in your paintings will lack impact.

Step-by-Step: Color as Value

The word *value* used in describing color means the lightness or darkness of the hue. In this study we do not change the hue; we change only the *value*. If we say *pale pink*, we're speaking of a light-value red; if we say *maroon*, we mean a deep-value red. Whether we say *sky blue* or *navy blue*, the hue is still blue, just the value is different. To lighten the value, i.e., *pale pink* or *sky blue*, we add white. To make the deep value red—*maroon*—and the deep value blue—*navy blue*—we add black. But adding black sometimes changes the hue; for example, black added to yellow does make it darker but the yellow changes hue and becomes green. To make yellow darker and *not* change its hue we must add raw umber. (We call a deep value yellow *brown*.)

In our Color-as-Value Chart at right, you see titanium white at value 1 become progressively darker toward black at value 7 as you move across the top row of squares from left to right. Each color also has its own row of squares (horizontally) and is painted in progressively darker values between value 1—white and value 7—black.

Each of these colors at full strength has its own intrinsic value built right into it. The position of the color on the

chart is predicated upon this value; for example, lemon yellow is value 2— light, and cadmium yellow orange is value 3—mid-light. Cadmium red light is value 4—midtone, while alizarin crimson, ultramarine blue, and viridian green are all value 5—mid-dark. Raw umber and burnt umber are value 6— dark.

Making a Color-as-Value Chart

By completing this chart, you will learn how to make any of these pigments lighter or darker without changing its hue. Working with this chart will greatly increase your awareness of value and your sensitivity to value change, of major importance to a portrait painter.

As with the preceding color wheel, you'll be saving the chart you make for reference.

Materials We will continue using oil, with more colors added. The rest of the materials remain the same: titanium white; lemon yellow; cadmium yellow orange (by Grumbacher; if Liquitex, use brilliant orange, value 7); cadmium red light; alizarin crimson; ultramarine blue; viridian green; raw umber; burnt umber; and ivory black.

Procedure On your paper palette, squeeze out about two inches of titanium white and about an inch of paint in each of the nine hues in the order in which they are given: White in the upper left corner of the palette, then lemon yellow, cadmium yellow orange, cadmium red light, and so on across the top to black in the upper right corner. Don't crowd the colors on the palette: We do not want one color to touch another. Carefully tear off this top sheet with the paint on it and set it to one side. You'll mix your colors on this sheet.

As we did in the Color Wheel project, slip this chart at right under the new top sheet of the paper palette; you'll be able to see the chart squares through the translucent palette sheet and trace them with a ballpoint pen.

Paint lemon yellow in its designated square under value 2—light, then cadmium yellow orange in its designated square, then cadmium red light, alizarin crimson, ultramarine blue, viridian, raw umber, burnt umber and black, each one pure, clean and unadulterated, in its square as printed on the chart.

Starting with lemon yellow at the top, you will see that it is already only one value away from white, so we need not do anything about mixing it to a *lighter* value. We must concentrate on mixing lemon yellow with raw umber to the darker values—3, 4, 5, and 6, in graduated progression toward value 7—black. Starting with the yellow, we mix raw umber with it, first in *tiny* amounts, then more and more, darker and darker.

Squint very hard to compare your lemon yellow-raw umber mixtures with the gray values at the top of the chart. Do you have a value 3 mid-light and 4, 5, and 6? If not, adjust your mixtures lighter or darker until you feel they are as close as you can get them. Paint the four lemon yellow values in their allotted squares on the top line.

It is not easy to mix color exactly to a precise value. *You have to squint hard to match a color value to a gray value.* This is excellent practice for your future portrait paintings where you must constantly keep judging color as value.

Try to paint each square a flat, even hue rather than streaking it with light or dark. And paint it out to the edges of the square, not just a blob in the center.

To lighten any of the oil colors, we add white. To darken a color (lower its value) without changing its hue, we need to know the following:

Lemon yellow is lowered in value by the addition of raw umber.

Cadmium yellow orange is lowered in value by the addition of burnt umber.

Cadmium red light is lowered in value by the addition of burnt umber.

Alizarin crimson, ultramarine blue, and viridian (green) are all darkened with black.

Raw umber and burnt umber are darkened with black.

VALUE 1 White	VALUE 2 Light	VALUE 3 Mid-light	VALUE 4 Mid-tone	VALUE 5 Mid-dark	VALUE 6 Dark	VALUE 7 Black
Titanium White (Pure)	Lemon Yellow (Pure)					
		Cadmium Yellow Orange (Pure)				
			Cadmium Red Light (Pure)			
				Alizarin Crimson (Pure)		
				Ultramarine Blue (Pure)		
				Viridian Green (Pure)		
					Raw Umber (Pure)	
					Burnt Umber (Pure)	
						Ivory Black (Pure)
VALUE 1 White	VALUE 2 Light	VALUE 3 Mid-light	VALUE 4 Mid-tone	VALUE 5 Mid-dark	VALUE 6 Dark	VALUE 7 Black

Moving on to cadmium yellow orange, we find we must mix this hue with enough white to make a lighter value corresponding to value 2—light. Start with white and add a small amount of yellow orange to it until you reach value 2. We know that this hue is darkened with burnt umber. Starting with yellow orange, add burnt umber bit by bit until you feel you have a value 4, midtone, value 5, and value 6. When you feel they are correct, paint them in their corresponding squares on the line with yellow orange, just below the lemon yellow-raw umber values 4, 5, and 6.

Now the top row of lemon yellow values from 1 to 7 is complete, as is the second horizontal row depicting the seven values of cadmium yellow orange. Aren't you already a little surprised at the very beautiful color value mixtures you have made?

Continue downward, row by row, with the other pure colors you have painted on the chart. All are *lightened*

Hint: If you would like to make this color-as-value chart using watercolor, trace and transfer the chart onto white paper. The same colors used in the oil chart will lower the values of the watercolor hues (darken them). See the shaded box on page 106. To make watercolor *lighter* in value, of course, you must add more *water* to the color rather than white pigment.

by white. Check the shaded box on page 106 for the pigment that darkens each respective color.

This chart, with all its subtle value gradations, will take some time to finish. Try not to rush it.

When you have finished, you will have each of our colors mixed to value 2, light—in a vertical column beneath the value 2, light gray square. They will all be very pale, their lightest. Under the value 3 mid-light gray square, you will have every color mixed to value 3, and so on under values 4, 5, and 6.

You will have an extremely beautiful Color-as-Value chart, and you will know a great deal about changing the value of a color without changing its hue. This chart is really helpful when you are searching for color harmonies.

Value and the Naming of Colors For auto manufacturers, interior designers, and paint salesmen—and the dozens of other professionals who deal with color but are not artists—the *name* of the color changes all the time. The words "pink," "rose," and "wine" are used to designate differing values of red. To the artist, "pink" is still a light value red. "Rose" is a middle-value red, and "wine" describes a deep-value red. To the artist, the hue has remained the same; only the value has changed.

More examples of these non-artist's color names and artist's hues are:
Peach is a value 2—light orange.
Rust is a value 5—mid-dark orange.
Aqua is a value 2—light green-blue.
Teal is a value 5—mid-dark green-blue.

Lime, celery, and apple are all value 2 or 3 light or mid-light greens.
Forest, pine, and cedar are all value 5 or 6 mid-dark or dark greens.

Value Awareness Skillful use of values is extremely important in painting portraits. Close values create harmony, while extremely contrasting values add excitement to a painting. A painting in light values (say 1 to 4) is termed a *high-key* painting, while one of values 4 to 7 is called *low key*. A painting done only in middle values may lack sparkle or punch; adding touches of strong lights and darks could revive it and give it contrast and life.

Note: Some teachers call values "tones." They will say, "a light tone against a midtone," meaning a light value against a middle value. In describing the values on a head, they may speak of "the light value, the midtone, and the shadow area." Don't let all this confuse you; the words are different, but the instructor is still talking about *value*—light and dark.

Checking Values To check values when you're working in color, photograph the painting in black and white (a Polaroid shot is good). If the darks are too black, you will know you have to lighten them. Frequently only an eyebrow or a corner of the mouth is too dark, or you may have painted the lights moving too quickly into the darks. These errors are easily corrected by trying to be more subtle.

Step-by-Step: **Color as Intensity**

In this project we do not change the *hue* or the *value* of the color, only the *intensity*. The word "intensity" here means the *brilliance* or *saturation* of the hue. A pure primary red, seen in bright sunlight, is absolutely at 100-percent intensity, a totally saturated hue. We say that this red is at its maximum "redness"; it cannot be any redder. To paint a 100-percent intensity red in oil or watercolor, we must have a pure red pigment, with no other color added to it, not black or white either.

Now let's move that 100-percent intensity red out of the sunlight and look at it under a porch roof. What do we have? The color is still red, but its brilliance is diminished; it's duller. Perhaps the red is seen now at 70 percent of its full intensity.

If we were to paint this red in shadow, we would say we need a low-intensity red. How do we get it? The color wheel presents the answer: We diminish the intensity of a color by adding its *complement*; in the case of red, the complement is green. To gray a yellow, we add purple, its complement. To gray an orange, we add its complement, blue.

The complement of any hue is found directly opposite it on the color wheel.

These graying processes work both ways, of course; as green diminishes the intensity of red, so red diminishes the intensity of green. As purple dulls yellow, the yellow diminishes the intensity of purple. As orange diminishes the intensity of blue, so blue dulls the orange. Lay a straight line across the wheel, through its center, from any hue, and you will arrive at its complement on the opposite side, whether the hue is primary, secondary, or tertiary.

If you mix enough green with your red so that your mixture is totally neutralized—appearing neither greenish nor reddish—you will have a neutral gray, the hue in the center of the color wheel.

Any hue, when mixed with its complement, is diminished in intensity.

Making Colors Appear Less Intense
The following exercise will show you how to make a color appear less intense—that is, how to tone down or neutralize a color.

Procedure You'll need the same materials as before, but squeeze out just three colors (no white or black): lemon yellow, alizarin crimson, and cobalt blue. Use a clean sheet from your paper palette, tear it off carefully and set it aside for a mixing surface.

Working with a ballpoint pen as before, trace the intensity charts, shown on the next page, as you see them through the next translucent palette sheet from the pad. You'll paint on this sheet. Paint the alizarin crimson (red) of your color wheel in the space at the left end of the first chart. Then put your color-wheel green mixed from lemon yellow and cobalt blue in the space at the opposite end. Paint each color out to the edges of its assigned space.

Make several mixtures of this red and green on your palette sheet and select the most neutral (neither reddish nor greenish) one. Paint it in the central space on the red-green chart.

Starting with the red, make more red-green mixtures and select those that you think should be in spaces 2, 3, and 4, moving from full-intensity red to neutral.

Then repeat the process with full-intensity green, painting gradations from green to neutral in spaces 8, 7, and 6. Repeat the procedure for the next charts using orange and cobalt blue, mixing the orange from lemon yellow and alizarin crimson. Then paint the third chart using lemon yellow and its complement, purple (made from alizarin crimson and cobalt blue). Again, allow them to dry and save your color-as-intensity charts and keep them handy for ready reference.

Hint: Neutrals made from the three different combinations are not the same neutral color. Each complementary pair produces a *different* neutral. Some are brownish, some gray, some more violet. Of course, none are brilliant colors. There are any number of other reds, yellows, and blues, too, and each pairing of these with their complements will produce a *different* neutral as well. You may want to work with them and prove this to yourself. The study of color is endless and always gratifying.

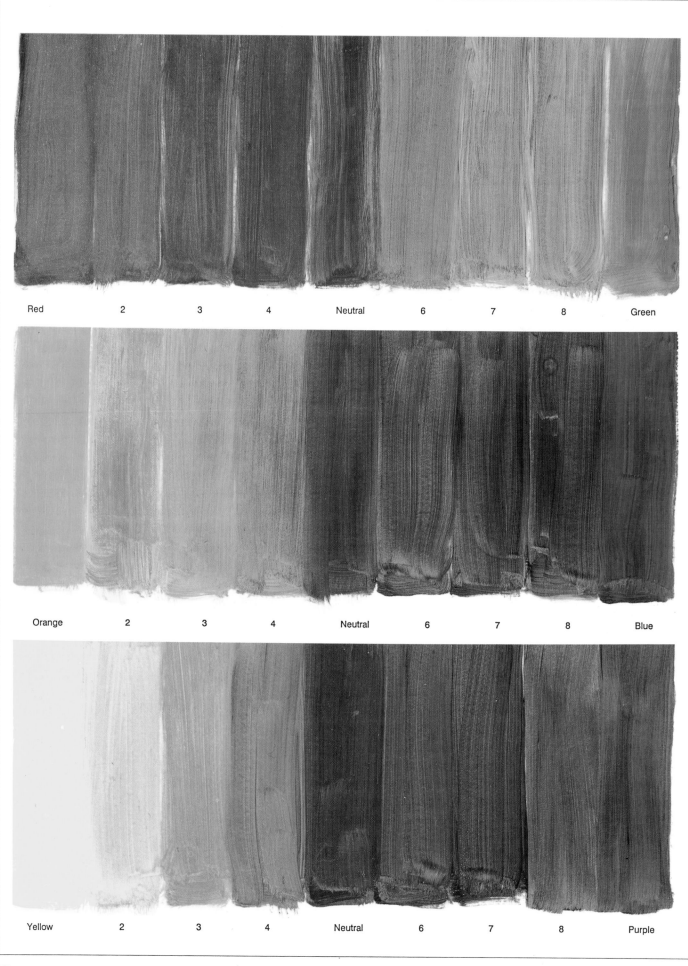

| Red | 2 | 3 | 4 | Neutral | 6 | 7 | 8 | Green |

| Orange | 2 | 3 | 4 | Neutral | 6 | 7 | 8 | Blue |

| Yellow | 2 | 3 | 4 | Neutral | 6 | 7 | 8 | Purple |

More Ideas for Neutralizing Color

It's useful for a portrait painter to recognize the quiet beauty of neutral colors, and that mixing complements is the best way to get them. You have learned how to gray, or neutralize, the primary and secondary colors. If you wish to experiment with tertiary colors (as complements), make similar charts and proceed as before. The tertiaries neutralize very quickly as they are already made from three other hues, which diminishes the brilliance of each hue considerably.

Totally neutral mixtures are not always made by mixing 50 percent of one color with 50 percent of its complement. For example, it takes only a very small amount of purple to neutralize lemon yellow, but it would take quite a good bit of yellow to neutralize the purple. Do you start with orange or cobalt blue in combining complements? Experiment and see which works best, but it's usually easiest to start with the *lightest* color when making a mixture.

Color as Temperature

Most all artists believe that yellows and reds are warm colors, and blues and greens are cool colors. Of course, this is an oversimplification; every color can be warmed or cooled. Yellows get warmer as they go toward red and cooler in the other direction on the color wheel, toward green. Even reds can be warmer going toward yellow and cooler leaning toward blue (orange-red or vermilion as opposed to cyclamen, fuchsia, or wine). Purples can go either way; they cool the red and warm the blue. This brings us to the understanding that color is really relative. In an all-green painting, even a pinkish purple will look hot. In a yellow and orange painting, a yellow-green will look cool! Each color is affected by whatever color is adjacent to it.

I hope you're beginning to understand our remark that "all color is relative." Sure, a red is a red, but as artists, we are in control—we can alter red dramatically by the hues, values, intensities, and temperatures of color we place next to it.

From now on, when we discuss painting flesh tones and say "warm or cool your color," you will know that the warm colors are yellows and reds, and the cools are blues and greens.

Making Colors More Intense

Color pigments have their limitations, but by using complementary colors we can make any hue appear *more* intense too. For example, to make red appear its most brilliant, we surround it with its complement, green. All greens—light, dark, bright, or dull—will intensify red. The following exercise involves painting squares within squares to explore this color phenomenon (see the charts on pages 112-114).

There is a half page of squares for each primary and secondary color. Paint specific colors in the outer squares surrounding each of the six hues and then study the results. You will see the way the same color *appears* to change from one square to the next, depending upon the surrounding hue, even though we *know* the color in the inside squares is precisely the same throughout.

Again, you will be using the primary colors plus ivory black and titanium white, laid out on a sheet of the paper palette. Carefully remove this sheet and set it to one side; you'll be mixing colors on this sheet. With a ball point pen, trace the squares from the Red chart on the next clean palette sheet. Paint the entire square at the left and each of the five inner squares alizarin crimson (red), right out to the edge.

Paint each of the five outer squares a different color as suggested, as smoothly as possible, trying not to let these colors get mixed into the crimson of the inner squares. Remove this Red chart from the palette and let it dry.

Trace the Yellow chart on the next clean paper palette sheet and paint the square at left lemon yellow, and all the other inside squares as well. Paint the surrounding squares as indicated. Remove this sheet and proceed with the other four charts in the same manner, painting the inner and outer squares as indicated.

Upon completing these charts, you'll understand how a full-intensity hue can be further enhanced by its complement and how an artist can push one color into an aggressive or a passive mode. Keep these charts for future reference.

Enhancing Intensity of Red

Red

Red and Black

Red and Orange

Red and Purple

Red and Dark Green

Red and Gray

Enhancing Intensity of Yellow

Yellow

Yellow and Black

Yellow and Green

Yellow and Orange

Yellow and Purple

Yellow and Gray

Enhancing Intensity of Blue

Blue and Green

Blue and Black

Blue and Orange

Blue

Blue and Purple

Blue and Gray

Enhancing Intensity of Orange

Orange and Red

Orange and Black

Orange and Blue

Orange

Orange and Yellow

Orange and Gray

113

Enhancing Intensity of Green

Green and Blue

Green and Black

Green and Red

Green

Green and Yellow

Green and Gray

Enhancing Intensity of Purple

Purple and Red

Purple and Black

Purple and Yellow

Purple

Purple and Blue

Purple and Gray

Color Ideas for Portraits

The Use of Complements

Do you begin to see the color wheel as a valuable aid to a portrait painter? Suppose your sitter has a very ruddy complexion—maybe too ruddy—and you decide you must de-emphasize the hot coloring. But you can't paint him without the vivid coloring or the portrait won't look like him. What can you do? One thing you know you *can't* do is paint the background green! Green would make the complexion appear even ruddier. If you use the hues nearer red on the color wheel, the vivid skin will contrast less with the surrounding background and appear more pleasing. On the other hand, you may *want* to emphasize a sitter's unusual red hair; using green in the background or clothing would help to accomplish this.

But changing the hue isn't all. By altering the value and the intensity of these nearby hues, many choices are open to us. It is recommended that you do several color studies before you begin a portrait, perhaps 5 × 7 inches or 8 × 10 inches large, so you can choose the very best color arrangement for your client rather than just settling for whatever is there.

Harmony from Analogous Colors

To ensure color harmony within the portrait, play it safe by using colors adjacent to each other on the color wheel: these are called *analogous colors*. For example, using yellow with yellow-orange and yellow-green will never present a color problem. Blue-purple with blue and purple would be another harmonious scheme. Use your inventiveness by altering the values and intensities of these analogous color ideas—then they will never be boring. One idea could be a large area of pale blue with a medium-sized area of blue-purple with a sharp blue-green used as the accent. Can you think of another exciting color idea using analogous colors?

Harmony from Split-Complement Color Schemes

A split-complement is a pair of complementary colors on the color wheel with one complement *split into the two hues adjacent to it*. Look at your color wheel and at the red-green complement. Split the green into the blue-green and yellow-green on either side (eliminate the true green). There is your split-complementary scheme: red, yellow-green, and blue-green. Blue with red-orange and yellow-orange is another. Yellow with red-purple and blue-purple another. Blue-purple with yellow and orange still another.

These combinations are slightly more complex than a direct complement and can give a bit more unusual effect to your painting. You still have all the options of changing the values and intensities of one or all three of the hues.

Painting Flesh Tones

The first time I was confronted with a live model I thought all this talk about flesh tones was pretty silly. I said to myself, "What's so hard about painting flesh tones? I know how to find out how to paint them, I'll just mix the color to match the skin on the back of my hand." And I mixed a color and tried it on my skin, and mixed and tried and mixed and tried, and after a while I began to understand what all the fuss was about. There wasn't any way to match that marvelous skin—for good reasons. Skin is made up of many thin and translucent layers; you can see blue, brown, pink, green—even lavender—there. Skin is a live organ made up of blood and tissue, muscle and cells, while we, as artists, have only paint—pigments made from natural earths, elements, or chemicals. We can paint a *semblance* of the skin, but we cannot match it. Remember, art is not life; art is the *illusion* of life.

Nevertheless, flesh tones always seem to be the biggest stumbling block for students of portrait painting. To get you started, we are going to mix them from just three colors plus white— what we call a "limited palette."

Using a Limited Palette and Oil Paints

We will be working on this chart of flesh tones with titanium white, raw sienna (Winsor & Newton), light red, and cobalt blue—less intense versions of the primaries. (By the way, light red is not cadmium red light; it is an earth color, like red clay.) Squeeze these four pigments out on a sheet from your paper palette, tear it off, and set it to one side for mixing. With a ball point pen, draw six panels the size of those from the *Flesh Tones in Oils—Limited Palette* chart below on the next sheet of the paper palette.

This limited palette exercise will simplify your first color portrait lesson, and you may be astounded at all these three colors plus white can do. In truth, this is a good choice of pigments for beginning any portrait, even after you have gained more experience.

Flesh Tones in Oils—Limited Palette

a. Titanium white and raw sienna

b. Titanium white and light red

c. Titanium white and cobalt blue

One Color at a Time Take the time now to familiarize yourself with these three colors by playing with them, intermixing them on your palette with the palette knife. Now take some white and mix raw sienna with it, making four mixtures in values from very pale to pure color. Using a brush, paint these mixtures in one of the panels *(a)* you've drawn, with the lightest value at left, darkest at right.

Then mix the light red the same way—and paint the four values shown in panel *b*, light to dark, left to right. Do the same with the cobalt blue in panel *c*. Cobalt blue is an expensive pigment but it is the clearest blue and is especially useful in flesh tones.

True Flesh Tone Mixtures Now intermix the white with raw sienna and light red, from palest tint to saturated color. Try it a bit more to the sienna, then a bit more to the light red. Paint these mixtures as shown in panel *d*. Do the same with white, light red, and cobalt blue. You'll find some beautiful grays for halftones and exquisite warm shadow colors here. Paint these hues as in panel *e*.

Then mix the white, raw sienna, and cobalt blue. You'll be surprised at the subtle warm greens you get from this combination. Make them pale to pure, then more golden, then more bluish. These are marvelous low-key greens for flesh. Yes, there are greens in the face and neck, very quiet ones like these. These mixtures should be painted as shown on panel *f*.

Hint: Always add color to white, not white to color, or you'll have mounds of excess color to contend with!

d. **Titanium white, raw sienna, and light red**

e. **Titanium white, light red, and cobalt blue**

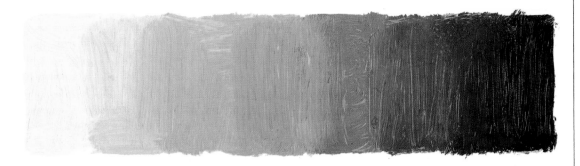

f. **Titanium white, raw sienna, and cobalt blue**

Darks for Flesh Tones and Shadows

Now tear off a fresh sheet from your paper palette and trace the panels shown below. On this sheet you'll be painting mixtures that'll give vibrant darks for flesh tones and shadows.

Mix raw sienna and light red together without white to make a hot burnt clay color. These two do not produce a real dark. Paint them the same as those in panel *g*. Then blend raw sienna and cobalt blue together without white. Here's a good dark! Make a brownish hue with more raw sienna, a deep greenish blue with more cobalt blue. Paint these the same as shown in panel *h*. Now mix light red and cobalt blue together without white. Good powerful darks: deep eggplant purple hue, deep red-browns. Paint this pair as you see in panel *i*.

Write in the names of the colors of each mix with a permanent marker, so you'll be able to refer to them when needed. Keep the charts handy for future portraits.

By now you're aware that light red has more tinting strength than raw sienna or cobalt blue. If you're not careful it will dominate every mixture it's in.

Flesh Color Families in Oils — A Full Palette

Study the chart on the next page. To do this color study, we will use the same method used previously. Squeeze the colors onto the top palette sheet and then set that sheet to one side. Trace the chart onto the next palette sheet and paint on that image. You will need the following colors: three yellows—Naples yellow, yellow ochre and raw sienna; four reds—light red, Venetian red, alizarin crimson, and burnt sienna; two blues—cobalt and ultramarine; and one green—viridian. Your small flat brush should do the work for you.

Each flesh color family is made up of two warms and a cool, plus white. Theoretically, a family could be made from any other pair of warms and a cool.

Complexions

A fair person with light hair has thinner skin than a person with a darker complexion, and therefore more blues are visible. In summer when these skins become tanned from the sun, the blues give way to warmer hues.

Red-haired people often have the thinnest skin of all. Their general skin tone may be extremely pale, very "white." Where their flesh tones do get warmer you'll see a unique coral or peach color, not a rose pink.

Ruddy complexions may be rosy red, red-orange, or red-violet color, and often have purples in the shadows and darks. Sallow skins have more yellow tones, are less rosy, and may be tinged with olive greens. Midtone skins on brunette people are often golden, more yellow than red, and have greens in the shadows.

There's also a type of "Irish" coloring with very black hair, fair skin, and really rosy cheeks, with hints of blue around the eyes and the temples where the skin is nearly transparent.

Dark complexions are seldom tinged with red but tend to gold-browns, orange-browns, with halftones toward violet, and sometimes pale blues in the highlights. Use combinations of cobalt blue and burnt sienna so you can vary the complexion either to the cool or to the warm. Try not to mix the hues too much on the palette but lay them side by side on the painting and blend them as little as possible to give the skin a feeling of life. At the nostrils, eye openings, and ears, you may want to add an earth red to bring vitality to the portrait, but study the individual first. (There are several earth reds, e.g., burnt sienna, light red, Venetian red, terra rosa, Pozzuoli red.)

g. Raw sienna and light red

h. Raw sienna and cobalt blue

i. Light red and cobalt blue

Flesh Color Families in Oils—A Full Palette

a. White, raw sienna, light red, cobalt blue; good for all-around basic flesh-tone beginnings. Good for men too.

b. White, raw sienna, Venetian red, cobalt blue; another basic mixture, but softer.

c. White, yellow ochre, burnt sienna, ultramarine blue; for medium to medium-dark complexions. More yellow tones here.

d. White, Naples yellow, light red, viridian; a luminous combination. Good for children.

e. White, raw sienna, alizarin crimson, cobalt blue; good for ruddy complexions, for warmer medium to dark skins. Also for warm shadows and darks.

f. White, burnt sienna, alizarin crimson, viridian; good for men and ruddy complexions.

Flesh Color Families in Watercolor

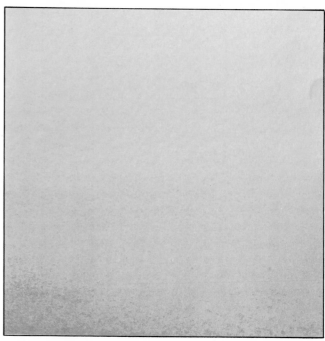

a. Yellow ochre + scarlet lake + cerulean blue. A good combination for an all-around flesh tone, especially for children; good first wash for all complexions.

b. Raw sienna + brown madder + cobalt blue. This is deeper than the preceding mixture; stronger, richer. Good for medium complexions; also for men.

c. Raw umber + alizarin crimson + ultramarine blue. Use for deeper colored complexions, but not reddish ones.

d. Cadmium lemon yellow + scarlet lake + cerulean blue. Luminous; used very pale, it's good for flesh tones in sunlight outdoors. (Use it stronger for complexions with more golden tones.)

Flesh Color Families in Watercolor

As in oil, each flesh color family in watercolor is made up of two warms and one cool color. Try these, then create your own combinations. Rather than darkening flesh tones with brown or black, which would make the mixtures dirty, add cools to the warm pairs and use less water to thin the pigment. This will give your watercolor portraits a clean, fresh appearance.

Procedure Mixing specific colors in watercolor is far less predictable than in oil. For your practice mixtures, use Arches 140-lb. cold-press or a similar watercolor paper with some tooth, and draw the squares similar to those at left, but measuring approximately 5 × 5 inches. Make eight or twelve panels, for some will be spoiled. Clip or tape your paper to the drawing board and prop it up at a 45-degree angle. The flesh color washes do not work so well on a flat board.

Squeeze out the following tube colors on a watercolor palette or a white dinner plate beginning at left: cadmium lemon, yellow ochre, raw sienna, scarlet lake, alizarin crimson, brown madder, cerulean blue, cobalt blue, raw umber, and ultramarine blue.

Take up a 1-inch flat brush and clean water and paint the first square *with water only.* While the paper is damp, add a wash of the first color in the family *a,* yellow ochre. Don't worry about going outside the lines. Keep a paper towel or tissue in your other hand to mop up drips. Lay this one color on from top to bottom, stroke by stroke *across* the square, and allow it to dry. *Under no circumstances should you go back into the wash, no matter how messy it looks; let it dry!* When dry, repeat the same process with a second clean wash of water, then add the second color, scarlet lake. You'll find this color very intense, so you won't need much pigment. When this wash is dry, repeat again with water, and, before it dries, add a wash of cerulean blue. As your board is tilted, the color will glide downward with the flow of the water, and so it should be stronger at the bottom third of the square. Just for fun, mix together the same three colors *on*

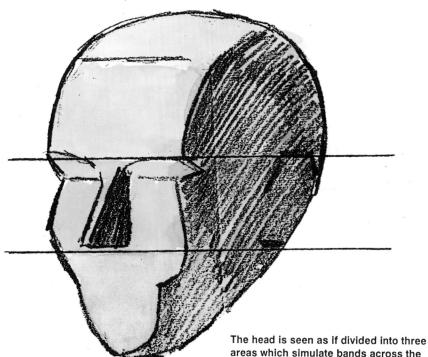

The head is seen as if divided into three areas which simulate bands across the face and head. The forehead band is seen as golden or yellow in color. The nose-cheek-ear band across the central part of the face is seen as warm, rosy, or ruddy. The chin and jaw band is cooler. The chin itself may show a hint of orange, but the lower chin and the jaw become bluer, grayer, or greener.

When starting the portrait head, the side planes, which are in shadow, are all one *value* and all one *color,* too. Only when the work nears completion do you paint any subtle color changes you see *within that value.*

your palette first, and paint one square. You will see that the results are not the same as with our glazing technique. Laying one color on at a time gives us a clear beautiful flesh tone, while premixing the same three colors gives us a gray hue.

It will take some practice before you get nice clean flesh colors, but in the process you'll learn a great deal about how much water to use, how much color, when the wash is dry and when it isn't, and many other things about handling this elusive medium of watercolor. You will get some marvelous clear transparent flesh colors. When you do, cut the best squares out and paste them on white paper. Pin it up on the wall for reference, recording the pigments used in each triad. Incidentally, you may want to start painting several squares at once so you can work on one while the others are drying.

Bands of Color on the Portrait Head

There is one more color idea to consider when painting the portrait head. As we discovered earlier on page 83, the *values* on the head vary from lightest on the forehead band, to slightly darker on the nose-cheek-ear band, to still darker on the chin and jaw. The *color* of the skin tone varies in a similar manner: the forehead band is more golden, more yellow; the nose-cheek-ear band is warm, more rosy, or ruddy; and the chin and jaw band is cooler. The chin itself may show a hint of orange but the lower chin and jaw is bluer, grayer, or greener. You can paint this head in color if you like, but it is here mainly as a reminder. If ever you find yourself working on a portrait and it isn't going well and you're not sure why, try this color system. It might help to make the head more natural, more interesting, more "lifelike."

Painting Hair

Shape, texture, and sheen are the qualities to emphasize when painting hair in a portrait. We also have to notice the way an individual wears his or her hair, the style; this is an expression of the personality and an important part of the likeness. Painting the hair well takes some observation, but it's not difficult—in fact, it's fun to do.

Like flesh tones, hair color varies considerably from one person to another, but there's one rule you can rely upon: natural hair colors are seldom the same color all over the head. You'll see lighter and darker places, warmer and cooler colors, all on the same head. Artificially colored hair, however, is not likely to have the variation of warm and cool lights and darks.

Painting Hair in Oils

Study this chart at right showing some hair colors mixed from a full palette. Try mixing these blends yourself, using the method for the previous flesh color chart. On a clean palette sheet, squeeze out the oil colors listed below. Remove that sheet carefully, set it aside, and trace the six rectangles on to the next clean palette sheet, then paint your hair mixtures in those shapes.

The colors you will need are titanium white, lemon yellow, cadmium yellow-orange, yellow ochre, raw umber, alizarin crimson, burnt sienna, cobalt blue, ultramarine blue, and burnt umber.

You will find you need a slightly different brushing method for painting hair. The quarter-inch flat brush is about right, along with a small pointed brush. Less mixing of the colors is required. Allowing the brush strokes to show lends a more convincing hair texture.

If you want a more smoothly brushed look, sweep your hair mixture very lightly in the direction of the strands of hair with the flat brush; this will give you the hair's sheen. (Be careful with this, as your work can become very slick looking if you "polish" it too much.) Following are the color mixes you'll find in a variety of hair colors, plus specific color traits to look out for.

Light blond Titanium white, lemon yellow (a cool yellow), raw umber and a touch of cobalt blue. This color hair is never really yellow; of course, lemon yellow and cobalt blue will turn green when mixed together—just be careful to balance them properly. For platinum blond hair, you really have to build up the lights in an impasto (thick paint). You might have to heighten them with white, allow them to dry, and glaze them with titanium white and lemon yellow to get them light enough.

Light brown, or "ash blond" Titanium white, yellow ochre, raw umber, cobalt blue. We want to avoid any look of red in this hair; raw umber is a dark yellow, and yellow and blue give us a green, so we will have to adjust these two carefully.

Red Titanium white (not much), yellow ochre, burnt sienna, alizarin crimson, cobalt blue, sometimes flashes of yellow-orange. The major color to use is burnt sienna, but you will see that mixing white with it kills its intensity.

You can heighten with white, let it dry, then glaze it with burnt sienna, or you can paint the lights with burnt sienna and use a slightly damp brush to lift out where you want the lights to appear, allowing the light ground to glow through. Darks are burnt sienna and purple made from alizarin crimson and cobalt blue. There are *never* any greens in red hair!

Dark brown White, yellow ochre, burnt umber, ultramarine blue. Warm the highlights with yellow ochre, cool the highlights with more blue. Too much white and they will turn gray so easily! Darks are burnt umber and ultramarine blue.

Black Ultramarine blue and alizarin crimson give a rich colorful dark, but you need to add burnt umber to give the color weight and body. Highlights are a cool blue from white and ultramarine blue, applied with a very light touch. Don't mess around in it! I never use black paint in black hair; black oil paint turns grayish when dry and doesn't have the depth of alizarin crimson and ultramarine blue.

Gray Titanium white, raw umber, cobalt blue. Observe this hair color carefully; often a gray-haired person has some dark hair as well! Raw umber and cobalt blue will do nicely for that. Usually people don't want yellows or gold in their gray. Your job is to paint gray hair in a very crisp and clean way so it doesn't look drab or "dirty."